What people are saying

The Problem with Stupid

With the deftness the topic deserves, Tom Grimwood pulls back the curtain on the cultural deployments and assemblages of "stupidity" rhetoric. In doing so, he offers a fair analysis unbound from ideological presuppositions (from "sheeple" to "Covidiots," the left and right have their own thorny practices), inviting readers to slow down and reflect on how stupidity claims serve as both sites of political struggle and foundations for mobilization. Between the always tricky poles of the earnest and satirical, *The Problem with Stupid* contributes to interdisciplinary literatures a masterful and lucid examination of this key trope and the interpretive boundaries it (re)produces. Not content to let "deeply persuasive and utterly cynical" stupidity discourse simply run amok, Grimwood ultimately points readers toward a hopeful politics of irony that can help us navigate the fractures and fissures of our times.

Don Waisanen, City University of New York

This striking book affirms and seeks to demonstrate Tom Grimwood's remarkable thesis that what we are living through today is the plague of ignorance as our pandemic. His very original contribution to this dialogue reflects on how the experience of the plague of ignorance renders us helpless, showing ways that the epithet of stupidity contributes to the medicalization of ignorance and its corporeal aura as an inevitable condition that seems immune to influence much like a chronic disease or even death.

In tackling the conventional epithet of stupidity and its prevalent use today, Tom Grimwood does a sociological analysis of this mood in popular culture or contemporary

society that laments the "fact" of collective impotence in the face of a widespread disease, seeing it as a feeling that the prevalence of ignorance seems unalterable. In this respect, Grimwood challenges the conventional sense of stupidity as an inarticulate insult in response to another opinion by using such a pejorative occasion to raise the question of how we might characterize work that we contrast from our own in dialogue that overcomes the temptation of polemic to set up discussion. This book succeeds in making such a meeting of minds possible in our society and at this time, as a hint that inquiry could be a vaccine.

Alan Blum, York University, Toronto

In a post-truth era, how do we deal with democracy? Why do we encounter so many stupidities in politics, media, and culture these days? Through stimulating analyses of public discourse and engagement with thinkers such as Foucault and Groys, Grimwood offers a surprising but convincing diagnosis: the problem is not that we or "they" become stupid, but rather that we live in a society that prompts us to deploy "stupidity" as a rhetorical weapon.

Nobutaka Otobe, Osaka University

The Problem with Stupid

Ignorance, Intellectuals, Post-Truth and Resistance

The Problem with Stupid

Ignorance, Intellectuals, Post-Truth and Resistance

Tom Grimwood

zer0
books

Winchester, UK
Washington, USA

JOHN HUNT PUBLISHING

First published by Zero Books, 2023
Zero Books is an imprint of John Hunt Publishing Ltd., No. 3 East St., Alresford,
Hampshire SO24 9EE, UK
office@jhpbooks.com
www.johnhuntpublishing.com
www.zero-books.net

For distributor details and how to order please visit the 'Ordering' section on our website.

Text copyright: Tom Grimwood 2022

ISBN: 978 1 80341 076 0
978 1 80341 077 7 (ebook)
Library of Congress Control Number: 2022935494

A CIP catalogue record for this book is available from the British Library.

Design: Stuart Davies

UK: Printed and bound by CPI Group (UK) Ltd, Croydon, CR0 4YY
Printed in North America by CPI GPS partners

We operate a distinctive and ethical publishing philosophy in
all areas of our business, from our global network of authors to
production and worldwide distribution.

Contents

Acknowledgements viii

Chapter 1
Turkeys Voting for Christmas 1

Chapter 2
Covidiots and Covexperts 16

Chapter 3
Zombified Intelligence in The Knowledge Society 38

Chapter 4
The Politics of Irony, Reconsidered 65

Chapter 5
Speaking the Truth, Again and Again 91

Chapter 6
It All Comes Down to Interpretation 114

References 138

Acknowledgements

I conceived the bulk of this book during the COVID-19 lockdown, and wrote it as the world began to adjust to the so-called 'new normal'. I would like to thank everyone who put up with me over those times, and those (often the same people) who provided encouragement for this project. In particular, I would like to thank Sarah Pemberton for her scrupulous proofing; Nancy Moules, Robert Williams, Alan F. Blum and Tristam Adams for their encouragement, constructive criticism and support for the writings that make up the book; and Abby, Elijah and Martha for their patience with my own stupidities while those writings were getting (or not getting) done.

The book draws on several previously published works: Chapter 2 is a modified version of Grimwood, T. (2021). 'On Covidiots and Covexperts: Stupidity and the Politics of Health'. *Journal of Applied Hermeneutics*. Chapter 4 is a revised and expanded version of a paper that appeared originally as Grimwood, T. (2021). 'The Politics of Irony, Reconsidered.' *Journal for Cultural Research* 25:1, pp.175-188. Chapter 5 is a reworked and expanded version of Grimwood, T. (2021). 'The Rhetoric of Demonic Repetition: The Two Deaths of Osama Bin Laden and Other Stories'. *Janus Head* 19:1, pp.77-90.

Chapter 1

Turkeys Voting for Christmas

It is common for these kinds of books to begin with the announcement – or reminder – of some malaise or crisis. Whatever else its achievements, critical theory has proved immensely effective at diagnosing *problems*, and such diagnoses form the basis of the broad brush strokes of critique and resistance that have coloured the twentieth and twenty-first centuries. Entirely in keeping with tradition, I also want to start this book by identifying a malaise, although one which is perhaps not as momentous or enthralling as others. However, the evidence of this malaise is all across public debate today, in opinion pieces and below-the-line comments, in blogs and amusing memes, in acerbic side-comments of keynote lectures and suggestive footnotes in articles. Still keeping with tradition, this malaise is complex and multi-layered, but straightforward to summarise: society is in the grip of an amorphous group defined as 'the stupid'.

The stupid emerge in discourses around the rise of and continual support for Trump, the persistent popularity of Boris Johnson in the UK despite a string of failures and embarrassments, the lack of a radical but consistent response to the 2008 financial crash and the austerity measures that followed, the misfortunes of social democratic parties across Europe when the policies of neoliberalism are so clearly failing, the absence of significant action on climate change in the face of scientific evidence, and so on. What links these is a cynical malaise: even the boldest of progressives may be indulging in widespread shrugs of despair, resigned to cliché. The turkeys are voting for Christmas, we sigh. And when society as we know it collapses under the weight of shallow populism, only

1

then will *the stupid see what they've done*. What hope is there for a progressive politics, we ask, when the electorate seems so ill-informed and ignorant, operating under a false consciousness which by now goes well beyond Marx's original formulation? Hence, when there is mention of the 'disenfranchised' or the 'left behind', we also find the stupid: 'they vote for extremes and populists because *they don't understand...*' When we ask what is to be done, someone mutters: 'brain transplants'. In times past, it was the shadowy figures of global neoliberalism, the lobbyists and the bankers, who were the obstacle to implementing effective left-wing policies. Now, even if all of these remain, there is a blunter and much more obvious impediment.

The stupid are also named as the building blocks of the culture wars, in their inability to see the end of the slippery slope it places us on, or the ludicrousness of the policies it is forced to create. While critics of Big Government tie themselves in knots, torn between libertarian disdain and a re-emerging enthusiasm for government to *just sort it out* by whatever means necessary, their sights frequently shift to 'the sheeple': those who claim to be intelligent, maybe intellectual, but lack the capacity to ask the right questions of the ideologies they blindly follow. Nassim Taleb (2016) refers to the self-serving 'Intellectual yet Idiot' (or 'IYI'): 'their main skill is capacity to pass exams written by people like them'. How dare such people talk of the people being stupid, they say, when their own views are so clearly flawed? How many times will identity politics lead to ridiculous and self-defeating practices in the real world? Marx's brief footnote on 'bourgeois stupidity' seems to have found a new life in anti-Marxist circles.

Across the political spectrum, voices accuse the stupid of remaining in a womb-deep sleep, failing to see the conspiratorial connections pervading a globalised world.

For the experts, the stupid question expertise without authority. For those who question expertise, the stupid accept

authority without question.

Where did they come from, then, this dangerously influential yet entirely contradictory group? Or to put it another way: why has intelligence become the battleground where sides are increasingly drawn, be it the fight over the naivety of the 'woke', the arrogance of the 'gammon', the idiocy of the Trump supporter, the shallowness of the 'Brexiteer', or something else?

Stupidity itself bears an etymological relationship to the idea of a 'type'. The Latin *stupēre* root term (to be stunned or numb) gives rise not only to *stupidus*, with its sense of stultifying astonishment, but also to *typos*, an impression or model, and to *typtein*, to strike or beat. In antiquity, then, stupidity carried the sense of being stunned still, whether by amazement or by violence. It was only in the seventeenth century that the notion of halting came to refer to a slowness of mind; and later still that stupidity was defined as ignorance. Indeed, in the nineteenth century Nietzsche describes stupidity not as an error or misunderstanding, but rather thoughts which are true but 'base' (see Deleuze, 1962/2006, p.98). This alignment is also at work in Gustave Le Bon's *The Crowd*, an 1895 treatise on mass psychology, which remains so persuasive it is reprinted almost every year. For Le Bon, stupidity is exemplified by the formation of the crowd: once inside, individuals become incapable of logical argumentation, and instead allow their behaviours and attitudes to change via the contagion of suggestibility. This is, in effect, the spreading stultification of critical thought, and it is clear that on this view stupidity – much like a virus – needs containment and reducing. Indeed, as Ernesto Laclau has shown, Le Bon's line between social organisation and mass crowds 'coincides...with the frontier separating the normal from the pathological' (Laclau, 2005, p. 29).

To some extent, the rise of this commonplace amid the increasingly complex and confusing world of the twenty-first century should be entirely expected. In an age of 'post-truth',

3

when evidence and argumentation seem so in question, it is perhaps only natural that our frustration boils over into insult within the mundane daily flow of posts, tweets and below-the-line comments. Within public discourse today the principles of dialogue, argument and critique that were previously established on the basis of specific audiences and clear pathological frontiers are now invoked in contexts where – due to the indeterminable reach of digital media – the specificity of the audience can only be represented and/or stereotyped, but not secured. Rather than fall flat as generalisations or stereotypes, the very insecurity of these arguments tends to create new specificities, in order that critical activity can resume. This is enhanced, if not facilitated, by a set of overly-repeated complaints by the 'non-stupid' in the last 20 years or so: the dangers of the World Wide Web, of course, and particularly the phenomenal infiltration of social media into traditional news outlets (in 2020, nearly 17 per cent of all news engagement on social media came from unreliable sources, compared to 8 per cent in the previous year (see Fischer 2020)); the either/or polemics that have dominated elections and referenda across the North Atlantic; amid populist contexts such as the Brexit referendum and the US presidential elections, the apparent rise of a disdain for 'experts' which Tom Nichols lamented as 'a Google-fuelled, Wikipedia-based, blog-sodden collapse of any division between professionals and laymen, students and teachers, knowers and wonderer' (Nichols 2014); the continual rumours of the final death throes of criticality brought about by the commodification of higher education (although, as Blaine Greteman once pointed out, this seems to have been a concern in the humanities since at least 1621).

These are all well-known monstrosities that recur throughout discourses of the intelligentsia regardless of methods and approach: the inattention caused by media saturation, the lack of depth caused by social media's endless clickbait, the destruction of rational debate caused by algorithmic filter bubbles and the

reduction of nuance to angry polemics caused by a combination of all of the above. But what do we *do* with the stupid? How do we negotiate the stupid in a meaningful way, other than with fatigued disdain? On a personal level, acknowledging that everyone can be a bit stupid sometimes is bound to help. I write this book as someone who regularly fumes at the senselessness of some common political arguments, which can in turn lead me to gross generalisations and throwaway stereotypes. I consider myself as much a target of the following chapters as the next person. But the problem also seems more endemic than personal. If critique and resistance depend on the mobilisation of intellect, what does the prevalence of stupidity as a commonplace suggest about the risks of such a mobilisation? As such, what are the resources to work through it, *outside* of simple and instinctive condemnation or insult?

The problem with criticism

Here, it starts to become clear that the grand narratives of the rise of the stupid I've mentioned so far only tell half a story, and I suspect it is this half-telling which grounds the non-stupid's despair with their dullard nemeses. This can be seen in some of the extant attempts to answer the questions above. The psychological questions we ask of these monsters ('why are some people stupid?') or the epistemological task (such as we find, to a lesser extent, in agnotology studies, which explore the necessary ignorance at work in any knowledge claims) tend to concentrate on stupidity at face value. That is, they see the stupid not only as a serious problem, but as a real species. That the stupid *exist* is never in doubt; they simply provide more details on where they appear, leaning on the textbooks of 'groupthink' and 'confirmation bias' (see, for example, Breakey 2020) which provide comfortable answers (so comfortable are these responses, and so readily do they sit among the mantras of critical theorists and management gurus alike, they often

overlook the lack of evidence behind them). In doing so, they tend to play down the strange concoction of triumphalism and despair that drives accusations of stupidity ever on. Psychology tells us that anxiety produces risk-averse behaviour, and anger produces risk-taking behaviour; but the rise of the stupid seems to produce both at the same time. If the turkeys really are voting for Christmas, and if the stupid really do exist, then we (the non-stupid) are both right in our diagnoses, and also already defeated in our aims.

Of course, stupidity exists. Of course, a psephology of the turkey coop may well have its benefits in some areas. But that isn't my interest here. Instead, I am more interested in whether the rise of the stupid suggests not only a mutation of ignorance, but also a failure of certain forms of criticism. To be blunt: at this point, it is sometimes difficult to see the difference between turkeys voting for Christmas and the repetition of political critiques and mores which are so comfortable, so obvious and so undeniable that they have long ceased to be effective. Nobutaka Otobe has noted that the historical inattention to stupidity – outside of its rejection or use as an insult – rests on what he describes as a dichotomy between 'the realm of solitary, righteous thinking' and 'ordinary human affairs comprising stupid politicians, bureaucrats, and the masses' (2020, p.1). But the criticisms of stupidity which emanate from such a solitary realm have become increasingly worn and comfortable, replete with symptoms of what Peter Sloterdijk once described as cynical reason: 'a clearly structured playing field with well-known players, established tactics, and typical fouls. Each side has developed certain, almost rigged, moves of critique' (1987, p.90). Bruno Latour's infamous essay 'Has Critique Run out of Steam?' suggested that the traditional approaches of critical theory were now all but indistinguishable from those of conspiracy theorists, and often less successful. Thus, when the International Flat Earth Research Society (which Wikipedia

wittily terms 'a global organisation') was revived in 2004, and enhanced through its connections to global conspiracy theories, the response of the non-stupid – which ranged from sharing endless memes and jibes to creating online guides for 'how to argue with a flat-earther' – overlooked how both sides were activating particular sets of clichés, fixating on aspects of knowledge and deploying commonplaces which were essential to their own critical activity, but not always understood *as* commonplaces. Hence, Lee McIntyre notes that 'perhaps Flat Earth wasn't so much a belief that someone would accept or reject on the basis of experimental evidence, but instead an *identity*' (2021, p.16).

To this extent, the number of clichés I have mentioned so far is no coincidence. To think about the stupid is to understand it as a commonplace, deployed across the field of cultural rhetoric in a way which is both deeply persuasive and utterly cynical. In this sense, the clichés of stupidity are the other half of the story: not simply in terms of repeated tropes, but in terms of the habits, rituals and interpretations which allow the deployment of the commonplace of stupidity to be effective in this way. We can frame this cynically – in the way Tom Boland notes how much of 'contemporary critique...reserves a special position for individuals who, somehow, heroically critique the society around them, even though most of the individuals they co-exist with are stupefied by ideology' (2019, p.19). But this leaves the obvious question: so what?

My suggestion in this book is that stupidity is interpreted as a particular argumentative device, a trope that is part explanation, part insult, which is embedded within an inherent plurality of interpretations that constitutes the current field of public discourse. In his book *Stupidity in Politics*, Otobe comments on how the dimensions of the plurality of our everyday affairs place the cliché as a key site of public discourse:

The modest acknowledgement of plurality goes beyond the mere recognition of the plurality of actors in the political realm. In fact, what stupidity tells us is how communicative interaction among plural forces is at work among our thinking activities. This is why clichés – words of others – constitute the quintessential phenomenon of stupidity. Our thought is not a result of solitary activity, but the outcome of plural forces' circulating within and beyond individual thought. (Otobe, 2020, p.5)

I propose taking this a step further: not only are clichés seen as stupid, 'the stupid' themselves (whoever they are) are now a cliché of public discourse. Importantly, this is not to dismiss or devalue the work of the commonplace. Rather, rooting the stupid as a form of cliché allows the richness of this form, and its relationship to the political, to be examined before we drift into the rather unsettling discussions as to what stupidity actually *is* (Derrida, for example, comments that insulting somebody as stupid only serves to highlight that the word 'cannot be absolutely translatable'. It is 'an indeterminacy between a determinacy and an indeterminacy' (2009, p.173)). The composite nature of the commonplace as an argumentative device – which allows it to shift and change in terms of its constitutive venom, humour, insight, despair and so on – is key to its effectiveness, and why it is so ready-to-hand in daily discourses. Like many clichés, the commonplace of stupidity is frequently explained only in terms of removing it or clarifying it until it is rendered more meaningful or serious. However, like any effective commonplace, it also develops in relation to networks of other commonplaces and clichés which help to tell the other half – or at least some of the other half – of the story. In Chaïm Perelman and Lucie Olbrechts-Tyteca's words:

The triteness characteristic of what we today call

commonplace does not in any way exclude specificity. Our commonplaces are really merely applications of 'commonplaces' in the Aristotelian sense of the term to particular subjects. But because the application is made to a frequently treated subject, developed in a certain order, with expected connections between the loci, we notice only its banality and fail to appreciate its argumentative value. The result is a tendency to forget that loci form an indispensable arsenal on which a person wishing to persuade another will have to draw, whether he likes it or not. (Perelman and Olbrechts-Tyteca, 1969, p.84)

Hence, I want to consider the stupid as a commonplace – a trope, a tool, a powerful cliché within the arguments of cultural rhetoric – in and of itself: that is, a relational assemblage governed by interpretative practices. This is to understand the cliché as a site of tensions and persuasiveness, not to be dismissed out of hand but to be understood in terms of their often-contradictory meanings; a task which dates back to the Sophist rhetoric of Classical Greece, its revival in theorists as diverse as Jean Paulhan, Roland Barthes, as well as Perelman, and its application in fields well beyond literature such as Susan Sontag's classic text *Illness as Metaphor* (where she claims that 'the metaphors and myths', the ready-to-hand commonplaces of illness rooted in war and violence, 'I was convinced, kill').

The rise of the stupid

The metaphors and myths accompanying the rise of the stupid at such pace and in so many areas through the first 2 decades of the twenty-first century suggest a mutation from the more traditional theories of ignorance proposed in, say, Marx or Freud. For Marx, ignorance was rooted in bourgeois interests shaping what counted as legitimate knowledge. Thus, 'scientific standards and forms of social rule...co-constitute each other'

(Harding 2006, p.24). Ignorance – both the exclusion of and alienation from some forms of knowledge, and of the recognition such exclusion has taken place – is thus systematic, addressed only by political interventions in epistemology. For Freud, the role of the unconscious was key to unpacking the preoccupations with beliefs and behaviours in particular cultural and historical eras. Yet, as Franco 'Bifo' Berardi has pointed out, the problem with cultural ignorance is no longer alienation, but an excess of communication; a shifting array of networks of information and meaning which constitutes the third millennium. This is visible in the sheer number of ways the stupid are figured – or disfigured – across otherwise unconnected cultural tropes in the 2000s and 2010s. The sprawl of the stupid's origin is best seen, not in the grand narratives of liberal intellectualism, but rather in sites such as the publication of Wendy Northcutt's book *The Darwin Awards*, which brought the reach of human stupidity into the popular imagination (while the awards had been running for many years before, the books propelled the idea of expulsion from the gene pool to a mass audience in 2000); *Pop Idol* first aired in the UK in 2001 (*American Idol* began the following year), premised in part on the lack of self-awareness or appraisal of some contestants; the current epitome of 'lowest common denominator' cynical reality television, *Love Island*, began in 2005 and continues to air; Paul W. S. Anderson's *Resident Evil* and Danny Boyle's *28 Days Later* both updating the zombie film genre and re-popularising the threat of the walking brain-dead in 2002; in the same year, Susan Powter's *The Politics of Stupid* claimed that rising obesity was related to 'acting stupidly', with 'common sense' strategies for overcoming this; the industry of New Atheist publications and debates between 2004 and 2011 trumpeted a coarse form of cognitive rationalism as a divider between the secularised worthy and the unworthy, with its main protagonists reappearing in several of the ongoing 'culture wars' of the 2010s. And so on.

All of these may form part of the interpretative horizons which are key to re-engaging, or perhaps even overcoming, the dominance of the stupid in the twenty-first century; just as the division and tone of such treatments mutated into applied political arenas, from Michael Moore's *Stupid White Men* in 2004 to Michael Hayden's 2018 *The Assault on Intelligence*, Crystal Marie Fleming's 2019 *How To Be Less Stupid about Race* and Keith Dowding's 2020 revision of Bill Clinton's unofficial campaign slogan, *It's the Government, Stupid*. Accompanying these are the steady adoption of so-called 'behavioural insights,' which Gregory Mitchell argues (2005) replace the assumption of equal rationality between people with an assumption of equal incompetence. Indeed, Daniel Kahneman and Amos Tversky won the Nobel Prize for Economics for their foundational work on the subject: in their studies, they suggested the main driver for people's actions was not the rational choice theory that 1980s economics had suggested, but rather a cocktail of ignorance, bias, and heuristic reasoning. In 2008 Richard Thaler and Cass Sunstein published their book *Nudge*, which captured the popular imagination by suggesting ways in which such biases could be manipulated in order to instil change. It contributed to the enthusiastic formation of behavioural insights teams in both businesses (as George Akerlof and Robert Shiller describe in their masterpiece, *Phishing for Phools*), and in the then-UK prime minister David Cameron's administration in 2010. By 2020, the former chief adviser to Boris Johnson, Dominic Cummings, referenced 'groupthink' – the theory that the need for consensus in a discussion will lead people to adapt their behaviours and agree to things they would otherwise criticise – as his main explanation for the UK government's failings in responding to the COVID-19 pandemic. Hugely popular in management toolkits and, it seems, among government policy advisers, groupthink has no substantial empirical evidence for existing; nevertheless, it reinforces the commonplace of the

stupid excellently.

It is pointless regurgitating yet again the glacial clichés of youthful inattention and the decline of critical thought that seem to dominate the view of who the stupid are and what they want. Pursuing stupidity as a commonplace means there is little point in surveying all the existing theories and arguments in order to present some kind of superior definition or conclusion. Commonplaces are effective because of their repetition in localised places; not because of their objective meaning. As such, the nature of my inquiry and the means to approach it via the assemblages through which stupidity emerges is quite deliberately not attempting yet another 'final word' on the subject. Firstly, this is because commonplaces will always struggle to make sense when treated as a conventional, distanced object of study, and secondly (and more bluntly) there is no sense adding one more claim to enlightened non-stupidity to the existing marketplace. As I have argued elsewhere (Grimwood, 2021), it is possible to face clichés without condemning or defending them outright, but rather by picking out the way they work within sites of practice. Working in this way means that what I am presenting here is also partial, necessarily incomplete, and possibly ignorant.

What follows in this book, then, is not so much an 'argument' in the traditional sense, but rather explorations based on several concerns arising from the previous discussion. It is certainly not some kind of pious condemnation of anyone who dares to call another foolish. This would be a stupid move on my part given that, as I have said, stupidity certainly exists. Instead, much of what I suggest here takes a complimentary angle to Otobe's claim that stupidity is not the opposite of thinking, but an inherent problem within it: 'we become stupid because we think' (2021, p.102), and, as such, it is impossible to demarcate one from the other by any pre-given standard. If this is the case, then the deployment of stupidity as an insult, or more

specifically a way of organising public debate, has an important stake in how such debates play out. This requires engaging with stupidity as a form of curation or arrangement of current events and cultural archives: in other words, in the face of the nostalgia for clear and solid 'answers' to the stupid, a turn to interpretation and cultural hermeneutics. By exploring the deployment of the figure of the stupid and considering what makes it so persuasive – what different aspects and assemblages of cultural rhetoric provide its power as a trope in public debate – we can reconsider political action, particularly that which is stymied by the malaise of stupidity.

A primary concern for me is the certainty with which the deployment of stupidity stands; that, despite the complexity and confusion, the threat of the stupid ignites a faith in the return of firm ground of unquestionable truths and irrefutable methods in politics and epistemology – rationality, data, genealogy and so on – which govern many of the responses to the so-called 'post-truth' era. 'When liberals speak of "fake news," they totally miss the point,' Franco 'Bifo' Berardi (2021) comments, 'because those who share a mythology (or a meme) are not searching for the factual truth, like a social scientist might. Instead, they are consciously or unconsciously using the force of the fake enunciation as an exorcism, as an insult, as a weapon.'

What I'm interested in here is not so much the weaponisation of myth, but rather how the foundation of truth method brings to light the limits of our interpretative practice. This is particularly notable considering how the growth of digital media has not only brought in the age of hyper-attention and its accompanying threats to civilisation, but also an overwhelming sense of nostalgia which Simon Reynolds has termed 'retromania' and Mark Fisher once described as the anachronistic cultural inertia of late modernity. Alongside the nostalgia for music and video games referenced by Reynolds and Fisher, there is a

correspondingly uncanny yearning for purity of public debate. In a 2012 episode of the BBC's *Newsnight* a panel discussion on drugs included, among others, comedian and ex-addict Russell Brand and essayist and *Mail on Sunday* writer Peter Hitchens. 'Why is a comedian being given a programme on the BBC to push a policy about drugs?' Hitchens asked angrily, before dismissing Brand's questions as *ad hominem*. But Brand, the panel host pointed out, had first-hand experience of addiction, whereas Hitchens did not. Indeed, Hitchens advocated for the return to Victorian deterrence measures which most academics had long rejected. Nevertheless, Hitchens proceeded to accuse Brand of 'debasing' the discussion by offering 'nothing based on reason, thought or fact', an accusation which suggested far more aspects than those three things were involved in determining the right to speak with authority.

There seems to be a need to think about the relationship between stupidity and its prominence in public debate, with the late-modern knowledge economy and the role of the intellectual within it. Just as the early twentieth-century developments of IQ testing in the United States reflected concerns with economic immigration, the work of the likes of Berardi and Christian Marazzi would suggest the concern with the stupid in the early twenty-first century is inherently linked to accelerated developments in global capital: a shift from the blue collar of production to the white collar of semiotic circulation, the birth of 'semio-capitalism', and the importance of the knowledge economy as the fundamental – yet utterly malleable – basis of late-modern industry. So, of course, one might argue, stupidity is a problem: it is not just foolish, it is unproductive. 'I would get so much more done if I didn't have to spend all my time dealing with idiots.'

By virtue of this, there is a question as to whether the condemnation of the stupid constitutes a bold effort to speak truth to power, or a perpetuation of certain modes and limits

of thought. As Marazzi argues, the meaning of knowledge, particularly as a weapon of critique, becomes entirely dependent on the spaces from which it is interpreted: intellectual resistance cannot escape the knowledge economy, in this sense. This suggests a challenge to the nostalgia for clear and distinct 'answers' to the problem of the stupid; indeed, such answers may turn out to be more aligned to what Charlie Brooker (2021) described as the 'effortless, narrative-free content in which pointless shit occurs endlessly' on YouTube and TikTok than they care to acknowledge. The politics of the stupid – the deployment of its clichés and its uses as a territorial distinction between right and wrong, good and bad, worthy and unworthy – is not a simple matter of qualifications but rather based on an array of resonant themes in both current academia and the history of intelligence, combined with what Aaron Jaffe describes as the distributive principle of pop cultural connectivity (2019, p.48).

All this coalesces around a final concern: how can the deployment of stupidity be critiqued without succumbing to anti-intellectualism? The answer, I think, is broadly this: that if this commonplace, this cliché of the stupid, is so persuasive and powerful – to the extent it has come to dominate public discussions of politics, public health, economics, and popular culture – then there seems to be a fair bit to learn from stupidity: not from the etic distance of an observer, or from a faux-naïf embracing of the idiot, but as an active interpreter who will never quite escape it, and must live within its tensions to continue to contribute critical thought to public debate.

Chapter 2

Covidiots and Covexperts

Analysing the advent of what he terms our current 'Burnout Society,' Byung-Chul Han points to the problematic role of immunology as a framework for interpretation. 'The past century was an immunological age,' he argues. 'The epoch sought to distinguish clearly between inside and outside, friend and foe, self and other…The object of immune defense is the foreign as such' (2015, pp.1-2). From mainstream political theory to Marxist, feminist and postmodern alternatives, the fundamental category of immunology is the Other. In this way, immunisation has provided an interpretative language: a set of metaphors and allegories which links together otherwise disparate concerns in medicine, politics and technology.

Yet for Han, this immunological model is insufficient to describe the workings of twenty-first century late capitalism with its globalised networks and dissolution of boundaries. If the model of immunology leads to disciplinary responses – the type of organisational control which was described so well by Foucault's account of institutions such as hospitals and factories, and Deleuze's musings on societies of control – for Han we now live in an *achievement society*. Here, the negative trope of control is replaced by an excess of positivity: 'prohibitions, commandments, and the law are replaced by projects, initiatives, and motivation' (2015, p.9). The problem is no longer an external Other, but rather the demands of self-fulfilment, demands which require our (metaphorical and literal) immune responses to be suppressed 'so that information will circulate faster and capital will accelerate' (2017, p.83). Amid the mass exchange of knowledge via communication networks which are no longer concerned with borders and

have absorbed all forms of otherness, Han suggests 'the idiot, the fool' – the one who performs an 'inner contraction of thinking to make a new beginning', who 'wants to turn the absurd into the highest power of thought' – has 'all but vanished from society' (2017, p.81-2). The idiot, Han argues, being 'un-networked and uninformed,' would stand opposed to 'the neoliberal power of domination: total communication and total surveillance' (p.83); if only the achievement society allowed for the stupid.

It is fair to say that the COVID-19 pandemic has necessarily and pointedly re-introduced immunology into our models of thinking, while simultaneously retaining the hallmarks of Han's achievement society. Consequently, it should be no surprise the extent to which the pandemic has highlighted the significance of the politics of health as an ongoing interpretative event. That is to say: the effectiveness of health delivery is in negotiation with day-to-day arguments in the public sphere, not just by 'experts' in peer-reviewed papers, but also (and perhaps predominantly) in the everyday interpretations and discussions of available expertise in print and digital media platforms. There is no separation of communication networks. Hence, the emergence of a pandemic of a previously unseen virus is, as Carley et al. suggest, 'arguably...one of the greatest challenges to EBM [Evidence-Based Medicine] since the term was coined' (2020, p.572). For clinicians, they note that the emergence of a new pandemic in a digital age is problematic because of:

the sheer volume of new 'evidence' that we are faced with. On the one hand, this research can be both informative and hypothesis generating, but on the other hand, it is prone to selective promotion and can overwhelm the user by the nature of volume and the frequency of publication. (Carley et al., 2020, p.574)

The same issue is at hand in the public discussion of how best to deal with the virus: the lack of clear and well-established protocols, the variations in approaches taken by different countries and, particularly of note in the UK, the ways in which its key themes – global travel and border control, state-sanctioned lockdown and welfare provision, considerations of society's 'vulnerable' and the legacy of downgraded public health investment – interweave into existing political arguments. As a result, discussion among the general public around whether to accept or reject a particular health intervention frequently take place in the same public forums, particularly on social media, in which these existing political debates take place. In this way, one can easily suggest that the decisions made by members of the public on whether to wear a mask, whether to visit a general practice, and whether to conform to social distancing rules is mediated at least in part by interpretations of the volume, frequency and promotion of certain views, on social media no less than in the world of EBM. Precisely because of this, the debate over public health and individual behaviour within the COVID-19 pandemic has been framed by the longer-term interrelationship between politics and health, and in particular the critical discussion over the role of expertise in the time of digital media saturation; one which has challenged the health professions as much as any other. This is what Paul and Haddad describe as a 'new truth regime, [where] politics seems to have unilaterally withdrawn from the social contract and appears to operate, once again, primarily on the basis of a stubborn will to ignorance and blatant forms of denial' (2019, p.300).

So much, we know. Post-truth has been heralded as the ultimate threat to intellectual civilisation, embedded in the rise of the alt-right, left-wing populism, alternative facts, fake news, and despite the clear lack of definition holding any of these together (as Frieder Vogelmann has rightly argued), a

strident demand to return to a clear boundary between the true and the false, the sovereign and the Other, a full-scale restoration of our collective immune system regardless of whether or not such a thing ever existed.

What, though, of Han's 'idiot'? Do they return, like the immunological model, and if so, in what form? It is, rather than the idiot, the stupid who have seen an increasingly febrile role in public debate. The interpretative distinction between the stupid and the intelligent, the unreflective with the rational and the conspiratorial with the informed has long been found in arguments against the more general, pre-COVID 'anti-vaxxers', the United States presidential elections in both 2016 and 2020, and either side of the Brexit divide in the United Kingdom. It is within the context of COVID-19, though, that specific questions about how such a commonplace is interpreted are brought to the fore.

It seems appropriate to illustrate the commonplace of stupidity through some examples of their primary vehicle for communication, the internet meme.

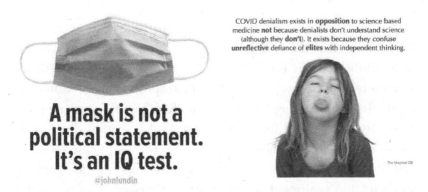

COVID denialism exists in **opposition** to science based medicine **not** because denialists don't understand science (although they **don't**). It exists because they confuse **unreflective** defiance of **elites** with independent thinking.

A mask is not a political statement. It's an IQ test.
@johnlundin

These are images and texts that are easily shared and viewed, at speed, across digital media platforms, in order to spread a message or viewpoint. In this way, the meme operates on a level of what Aristotle termed the enthymeme: that is, a unit of cultural transmission embedded within an audience's ability to

accept similarities across situations (as I have argued elsewhere, the claim that the meme was solely the invention of a certain R. Dawkins is telling in the ways it obscures this relationship to the meme's rhetorical past). Indeed, memes appeal to the manifestation of what Hans-Georg Gadamer described as the *sensus communis* underlying interpretative judgement: the common understanding which allows interpretation to take place at all. In this sense, these meme examples appeal to a clear argument: following science is the antithesis to being stupid. Those who do not 'follow the science' are, therefore, stupid. Accompanying the concern for the decline in the value of expertise, and the associated ascent of fake news and post-truth, the line is very clearly drawn in social media between those with intellect and those without; those committed to the value of fact over the allure of conspiracy. In such a context, the aim of the arguments around applied responses to the pandemic revolves around an established commonplace of digital rhetoric, encapsulated in a popular pre-COVID meme which asserted: 'science: it reduces the stupid.'

The ethos of the stupid

Isn't this obvious? Perhaps too obvious: the readymade accessibility of this form of critique renders stupidity a cliché. It is merely stating what we (the non-stupid) already know; the equivalent of showing a picture of a globe to a flat-earther (and typically with much the same effect; that is, none). But much like the use of clichés, something more is being appealed to than tautology. If the medium for these accusations is often irony or humour, the sentiment is certainly not flippant. This is not the 'oh, don't be so stupid!' that we might say to a partner or sibling. Instead, the mud is very much supposed to stick. After all, in the midst of a pandemic, the stakes are very real: a reasonable, evidence-based approach to public health initiatives is key to the prevention of further spread and deaths from the virus. This

is not the 'idiotism' which Han borrows from Deleuze, which is more of a celebrated instigator of new thought by virtue of their idiosyncrasies. Clearly, so-called 'Covidiots', while sometimes declaring opposition to various notions of neoliberal domination, are nevertheless entirely networked, fuelled by communication access and *au fait* with the language of reason and evidence. At the same time, the prevalence of this specific trope and its specific concern with expertise suggests it is something more than an *ad hominem* attack (even if it *is* that as well). And in that sense, it seems right to ask: what *kind* of stupidity is being referred to? If, as I have already suggested, these accusations of COVID-19 behaviours are embedded within the wider concerns for the fate of expertise in contemporary culture, then what are the wider interpretative systems used to frame them?

Of course, one readymade response is Gustave Le Bon's views on the pathology of the crowd, which has the added benefit of drawing on the same immunological language of a pandemic. But while such responses might resonate with discussions of the decline of expertise in the face of political populism, they do not in themselves shed much light on the meaning of stupidity *as a trope*: not just because of Ernesto Laclau's argument that Le Bon woefully fails to account for the myriad of ways people might group together and communicate while also thinking relatively logically, but additionally because Le Bon insists that mass psychology requires anonymity, and the loss of self. However, the targets of the memes above are not anonymous; if anything, COVID-deniers and anti-vaxxers are prominent not just in identifying themselves, but in their displays of (apparent) reason and evidence to support their claims. It is perhaps for this reason that another answer has become particularly prominent, which is the invocation of 'confident idiocy', or what has become known as the Dunning-Kruger effect. In a small experiment in social psychology, David Dunning and Justin Kruger asked participants to report on their

confidence in carrying out a task, and then compared this to how the candidates actually performed. They argued that there was a direct correlation between confidence and performance: the more confident a participant was, the less well they had performed. The study concluded that incompetent people were unable, and unwilling, to acknowledge their lack of competence, because this would require the very expertise that they lacked; instead, they will become more belligerent in their view of their own abilities. Arguments by anti-vaccination advocates and claims that COVID-19-deniers are seen as fine illustrations of this, as the direct reproach to established evidence bases is precisely what buoys the arguer. The louder one shouts about one's expertise, the less one is likely to know.

Unlike Le Bon, Kruger and Dunning's work is notable for its emphasis on the individual at fault: arguing that 'the miscalibration of the incompetent stems from an error about *the self*, whereas the miscalibration of the highly competent stems from an error about others' (1999, p.1127, my emphasis). This particular aspect of the Dunning-Kruger account of stupidity is often picked up by its proponents. For example, US blogger and obstetrician gynaecologist Amy Tuteur argues that the 'disparagement of expertise may boost the self-esteem of its promoters, but often harms everyone else. What confident idiots know rarely represents the sum total of all knowledge on the subject; that's why real expertise is worthy of respect' (Tuteur, 2016). Writing for *Forbes*, Ethan Siegel concludes that the Dunning-Kruger effect can only be challenged by a response based on one's *ethos* rather than *pathos*. It:

> requires a kind of transformation within yourself. It means that you need to be humble, and admit that you, yourself, lack the necessary expertise to evaluate the science before you. It means that you need to be brave enough to turn to the consensus of scientific experts...If we listen to the science, we

can attempt to take the best path possible forward through the greatest challenges facing modern society. We can choose to ignore it, but if we do, the consequences will only increase in severity. (Siegel, 2020)

This focus on character traits serves to cement that stupid people are not simply mistaken on the facts, they are also *morally* wrong. The change to be made is within the individual, in order that they are better able to 'listen to the science'. Clearly, in many instances of public debate, the emphasis on choice is one of moral imperative: to not wear a mask is to risk the lives of others; as is avoiding a vaccine. These are individual choices about our behaviours that have effects on the people around us, just as refusing to self-isolate or taking a holiday to North Wales are. In some cases, choice is emphasised precisely to frame an action *as* moral, rather than, say, economic (as in the case, for example, of the person who refuses to self-isolate because they work in the gig economy and can't afford to take the time from work). But more fundamental to our concerns here is the role of choice in accepting or not accepting knowledge. Inherent to this version of confident idiocy is a working assumption that we can pick up and use information as it passes us by, as we please. Therefore, if we choose wrong, we are stupid, and probably immoral for that.

Of course, this can be very convincing, especially when faced with the stream of sometimes bizarre claims and conspiracy theories which one can encounter on social media regarding COVID-19. But the more interesting aspect of the Dunning-Kruger research is that it bears significant marks of the *production* of expertise ('real expertise' that is 'worthy of respect'). For example, it is referred to as 'Dunning-Kruger', when the original paper has Kruger's name first. But it is not the Kruger-Dunning effect, because Kruger was at the time only a graduate student, while Dunning was the professor. Hence, when the Skeptical

OB blog declares in relation to the confidence we might have in expert views, 'that's why professional qualifications are so important', the wider implications of that claim are unwittingly reflected in the Dunning-Kruger example: that is, the darker side of what Jason Brennan has championed as 'epistocracy', or the advocacy of elite knowledge over and against democratic representation. *Titles matter.* Furthermore, Dunning and Kruger's original studies were of students at university. It is perhaps not surprising that over-confidence was a problem here: students who had reached tertiary education, often at great financial cost to themselves, may well be disposed to feeling a certain elevated confidence in their abilities. The use of students as participants is common practice in much social psychology simply because they are more readily available and easier to recruit than others, and this keeps the costs of an experiment down considerably. While it is therefore problematic to scale up these findings to those participating in internet debates – the self-confidence of the original participants was not *opposed* to expertise but embedded in the same system that produces it – such choices of data subjects represent what Paul and Haddad term 'convenient uncertainty' (2019, p.306): a choice made less out of intentional exclusion of non-students, but rather from 'agnotological convenience'.

For some people, these points are insignificant; the evidence from the experiments still stands and the observation is still astute. However, what I think these points demonstrate are the cultural and economic aspects of expertise which a simple line between confidence and competence does not attend to; as well as how convention and tradition is a key determinant to which forms of reasoning and illustration are used. What *is* significant is that the contemporary invocation of 'confident idiocy' takes place against the backdrop of a specific (though notoriously ill-defined) cultural context: that of 'post-truth'. This, too, is a context beset with agnotological convenience. The term 'post-

truth' has become, amid the genuine concerns over its political and cultural effects, a *de facto* victory of a positivistic certainty; and accompanying this victory is an industry of conferences, academic papers and even research centres that have arisen in its wake to determine who are the intelligent ones and who are the confident idiots. But in this response, 'post-truth' rather too quickly becomes merely 'non-truth', and the complexity of the 'post' prefix is lost. Too quickly, post-truth is shaped into a shorthand strawman figure to be bested by conservative epistemological mantra; a figure uncannily similar to older enemies of that same mantra, such as radical feminism, post-modernism or the hermeneutics of suspicion (see, for example, Calcutt 2016). Too quickly, the complexities of 'post-truth' become a cipher for nothing other than a yearning for an ideal model of academic institutions of truth and readily graspable 'facts'.

This is not to dismiss Kruger and Dunning's argument, and certainly not to deny that ignorance can be damaging to public health efforts. Instead, I would argue that there are certain rituals, processes and cultures of knowledge production which *remain* at work when peer-reviewed research becomes the content of public debate. If it might be tempting for the epistocrat to suggest that the invocation of Dunning-Kruger by a wider population leads to misrepresentation because, ironically, it is being utilised by non-experts, this merely repeats these rituals, processes and cultures once more. As such, this case highlights the way in which a beacon of reference for framing 'stupidity' carries with it a number of less manifest aspects of 'intelligence' in our time, which nevertheless constitute an interpretative horizon that is core to making sense of the cultural rhetoric of stupidity.

I use the term interpretative horizon here in the sense that Hans-Georg Gadamer utilised: that is, a combination of cognitive, normative and reproductive aspects of interpretation

which provide us with the necessary 'fore-understanding' to make any understanding possible (Gadamer, 2004, p.309). For Gadamer, we do not simply arrive at an object of interpretation – whether this is a person, a text, a sign asking us to wear a mask in this shop, etc. – from nowhere. Rather, we are instead always-already within a specific culture which provides us with 'prejudices' that enable interpretation to begin. While prejudices (which, for Gadamer, is not necessarily a negative term) rooted in our historical consciousness provide the means to interpret, each act of understanding involves a 'fusion' whereby the horizons of both interpreter and interpreted grow. As such, if we are to interpret the impact of these commonplaces of public debate on applied health interventions within the pandemic, then we need to attend to how such horizonal aspects facilitate the shorthand of 'reducing the stupid' which turns epistemology into moral requirement: that is, what cultures and rituals are maintained or perpetuated, and what this speed of judgement leaves out, or steps around.

Stupidity on (and in) the horizon

A prime reason that the pandemic brings this shorthand into focus is that, as Carley et al. argue, the pandemic provides 'a time when we can experience first-hand the journey from ignorance about the disease through to a better understanding and approach to diagnostics and interventional therapy' (2020, p.574). As such, one could argue that COVID-19 has shone a light on the processes of knowledge production which are more usually obscured either by a form of site-exclusivity (hidden behind the pay walls of academic journals or the real walls of the university and the laboratory), or the length of time such production usually takes due to funding, access to resources, ethical approval and so on; all of which has been accelerated in COVID-related research during 2020 and 2021. Furthermore, the political machinations of evidence – from the

micro academic rituals of Dunning-Kruger to the macro policy decisions, funding allocations and presentation of data of national government (see Ashton, 2020, pp.160-179) – have also been manifest. If this is the case, then it becomes increasingly clear that the invocation of stupidity is not a simple reliance on the 'facts,' however popular the positivist revival in public (and large parts of academic) debate might be. The rhetoric of '*the* science', in need of defending from the stupid, masks the complex yet entirely functional ways in which such science is *made meaningful*, and consolidated from a myriad of data into one single '*the*'. Or, in other words: to judge something as stupid requires interpretation.

The word ignorance stems from the Latin *ignorantia*, a lack of knowledge, but its long journey – via Middle English and Old French – to today's usage leaves a number of ambiguities in it. Arfini (2019), for example, notes that 'to be ignorant' and 'to ignore' are two quite distinct perspectives: the former suggests being uninformed or unlearned, the latter suggested an intentional refusal to take notice of something. This is echoed in the work of both McGoey and Paul and Haddad, who note in their respective fields of practice (sociology of health and policy studies) that rather than aligning ignorance with misinformation or falsehood, *choosing* to ignore aspects of a certain horizon can form 'very tangible effects of selective processing of research-based knowledge,' where 'ignorance emerges as a by-product in knowledge-making processes' (Paul and Haddad, 2019, p.308). On these arguments, ignorance is not the 'other' to knowledge, as the scientistic memes might suggest, but rather a material part of it. Knowledge itself depends on a level of 'strategic ignorance', if only to reach something like a 'conclusion' in a manageable form. As before, this begins to reflect something like a performance of what Gadamer terms the ontological 'effective-historical consciousness' which situates our interpretative acts: the horizon for understanding which is not universal in reach

but rather a 'range of vision that includes everything that can be seen from a particular vantage point' (Gadamer, 2004, p.301). This fluctuating frame of reference is shaped and changed by the limits of our situation and knowledge, and the ways in which such knowledge is significant to us. Our horizons are not simply operational knowledge of the world, but also our expectations, projections and hopes. Like prejudice, the strategic ignorance raised by McGoey and Paul and Haddad is not necessarily an obstacle to understanding. It is, rather, a condition of understanding itself: such 'fore-understanding' is 'what determines what can be realised as a unified meaning and thus determines how the fore-conception of completeness is applied' (Gadamer, 2004, p.294).

In this light it is noticeable that, like many in the field, Carley et al. utilise a narrative structure for ignorance whereby the concept emerges from a sense of assumed completion: in other words, ignorance is only a step on the way to proper knowledge. Hence, this is a 'journey', not an errant adventure. We start with nothing, in order that we finish in possession of understanding. This notion of possession – from not having knowledge to having it, from not having an appropriate therapy to carrying out an intervention with it, and so on – is instructive, and not just typical of health research. Indeed, in analytic epistemology possession is the keystone of both dominant views of ignorance: what is known as the 'Standard View on Ignorance' refers to it as a lack of knowledge (one cannot both be ignorant and have knowledge of a certain thing) whereas the 'New View' argues that it is the absence or lack of true beliefs (one cannot be ignorant and have a true belief about something). Both assume that knowledge, beliefs and truth are things that people possess, and subsequently exclude one from holding both at the same time.

But if possession is at the centre of knowledge, it cannot be a literal 'possession': after all, one does not physically pick up

knowledge in their hand. Storing memories is not exactly the same as storing real books (if it was, surely the distribution of photocopied handouts would have been far more successful in higher education over the years). Indeed, as Paul Mason has argued (2015), in an age where digital files can be infinitely reproduced, premising possession on scarcity – one has it or one doesn't – ceases to make sense. Instead, in all of the cases above possession serves as a practical – and highly traditional – illustrative structure. It is, in this sense, not just a description but also a trope in which certain conditions for understanding are established via the imagery of possession. Key to the effect of this trope is a binary rhetoric: one possesses something, or one does not, just as one has knowledge, or one does not. Hence, when we read that 'science reduces the stupid', we are clearly not meant to ponder on those parts of the history of science we would now think of as 'stupid', and whether that should be considered a longer-term part of the reduction. In this sense, such non-stupidity is both historical, in that it follows a temporal path in achieving its goals, while also being outside of history (both because its focus on 'fact' contests the hermeneutic effective-historical consciousness of a situated horizon, and because the *achievement* of its goal is always assumed: a vaccine, a herd immunity, etc.). This is what Vattimo and Zabala once referred to as 'the Winner's History' (2011, pp.37-9): it was, because it was always going to be.

As such, we may well stop and pause before the assumed 'completion' at work in the narrative structure of ignorance's journey to knowledge. Gadamer's account of the horizon and fore-understanding allows us to unpick some of the problems with this binary rhetoric; in particular, the modality of what Gadamer refers to, following Scheler, as 'knowledge as domination', (2004, p.447) which hermeneutics is opposed to. Instead, the responsibility of the hermeneutic encounter is to establish the relationships between the kind of ignorance or

stupidity in play, and the wider concerns around expertise and methodological rigour. It is precisely the domain of the commonplace – the enthymeme, the *sensus communis*, the internet meme – in which the persuasive work of the tropes underlying claims to understanding are at their most effective, but also at their most bare in terms of the limits they reveal.

At the same time, while Gadamer's argument that fore-standing determines our sense of how this journey can or will be completed, there is reason for caution around moving from this general account of ignorance as constitutive of knowledge, and what is at stake in the *specific* COVID-related invocations of stupidity, and of knowledge production in the time of pandemic. The caution revolves around this: for Gadamer, 'a person who has a horizon knows the relative significance of everything within this horizon, whether it is near or far, great or small' (2004, p.301). In this way, our understanding is formed out of an acknowledgement of our ignorance, the gaps or incompletions in our horizons, which requires a necessary open-ness to other horizons: 'working out the hermeneutical situation means acquiring the right horizon of inquiry for the questions evoked by the encounter with tradition' (Gadamer, 2004, p.302). This knowledge of significance is especially important to the clinician-patient relationship, and why Gadamer aligns medicine with rhetoric, with both requiring to know when to speak and when to remain silent, and 'the right kinds of discourse to exercise an effect on the soul in the right kinds of way' (Gadamer, 1996, p.41). I suggested earlier, though, that while the interpreter is aware of the relative significance of what is within their horizon, it is precisely the formative aspects of knowledge which are both pointedly *in*significant, yet banally effective, that trouble the simplicity of this 'journey' from ignorance to knowledge. Not only is this a symptom of Han's 'achievement society' – where interpretation is less a dialogue and more a constant curation of information exchange

– but furthermore, within the COVID-19 pandemic specifically, it is the question of significance which underlies the very effectiveness of certain public health interventions: from what constitutes a significant number of deaths or vaccinations, to how significant is leaving one's house twice for exercise or washing the car during national lockdown. In this way, one might suggest that, if only for the moment, measures such as national lockdowns which affect the entire experience of being (see Žižek, 2020, p.129) raise some interesting problems for Gadamer's account of 'relative significance' as differentiated from the insignificant, and consequently the understanding of one's horizon in terms of its open-ness to others, into question. As such, I think there is more to say about the construction of an interpretative horizon and the specific way in which stupidity is playing its role within the pandemic.

Models of the non-stupid, or colonial interpretation

In his critique of the UK's handling of the pandemic, John Ashton points out that the discourse around the virus has been dominated by limited forms of knowledge; namely, laboratory-based epidemiology and data modelling (2020, p.213). In the main body that advises the UK government, the Scientific Advisory Group for Emergencies (SAGE), there is a notable absence of public health experts, as well as historians of disease outbreak and anthropologists who, Ashton argues, would provide lived context – particularly of the interconnection between health, economy and society – for interventions.

The question I want to raise from this observation is not which discipline is best suited to supporting the COVID response, but rather how a narrow model of 'knowledge' affects the interpretations of stupidity under consideration. This, I think, suggests the adoption of a particular model of immunology which, unlike Han's account, is intrinsically related to both practices of health intervention and its requirements

of 'knowledge': that is, how the binary relationship between knowledge and ignorance is figured. Whereas Foucault once described immunology in terms of disciplinary institutions, this re-introduced immunology in the time of COVID, idiosyncratically placed within technologies that have, if Han is correct, outgrown it, can be described in terms of interpretative horizons that have already internalised the recognition of what is 'significant' and what is not.

It seems clear that a reliance on a narrow horizon of expertise risks what Charles Mills once referred to, in the context of race relations, as a 'closed circuit of epistemic authority', (2007, p.34) whereby the structures of approval reinforce their own narratives. Politically, when governments in the midst of a pandemic argue that they are 'following the science' or being 'guided by the data', the singularity of this claim – *the* science, *the* data – insists on a binary line between official intelligence and what might be cast as 'alternative facts'. The question becomes fixed on whether the science says x or y; or whether *this* science is better than *that* science (for example: the science of herd immunity versus elimination strategies). Within a digital mediasphere where not only is *the* data there, but also any number of YouTube conspiracy theories and re-presentations of that evidence, the circuit of epistemic authority is only closed tighter: regardless of whether I am supportive of COVID interventions or suspicious of them, I am right because of the data, and the data makes me right.

This is why Chris Anderson's polemic that the transparency and availability of data would lead to 'the end of theory' – 'with enough data, the numbers speak for themselves' (quoted in Han, 2017, p.58) – is troubled precisely by the prevalence of so much information. For the 'right data' to be identified as such, interpretation frequently falls back on the traditional means of demarcating truth from everyday thinking, even when the complexities of 'post-truth' problematise such means. We are

therefore left with an awkward juxtaposition of a complicated pandemic in need of complicated answers (research, policy, intervention, vaccine and longer-term social measures) next to a brute and simplistic view of stupidity. Yet this is not just an unfortunate by-product of internet aggression, or a careless insult used one too many times. The themes that we have identified so far – embedding facts in a system of elite institutional practices, the alignment of intelligence with possession, the spread of knowledge as a moral duty through tropes of journey and travel, and an aggressive distinction between all of these and an under-developed, 'stupid' other – all echo a spirit of interpretation that utilises the notion of ignorance as core to its own value; a spirit which we might have once described as *colonialist*. Such an interpretative colonialism borrows the motifs of binary distinctions (civilised versus stupid) and traversing borders (the 'journey' of knowledge about COVID, and specifically of vaccinations, is expected to consolidate in the Global North before finding its way to the poorer nations).

Stupidity thus becomes not only a display of ignorance, or an act of immorality, but one of barbarity: a wilful destruction of evidence, and consequently the health of a population. Barbarity, as we know, is the hallmark of the barbarian: a term originally coined for those who did not speak Greek in the classical world, the name mocking the uncivilised noises that came from their mouths. In the history of stupidity, insults are always intertwined with interpretative strategies. There is also a colonial resonance with the nostalgia for interpretative certainty, and indeed the tropes which present ignorance and stupidity as mere steps towards their obliteration – journeys, possession, binary moral choice – are imposed at the expense of the tensions and contradictions within the pandemic's social, cultural and political effects. If such nostalgia may appear anachronistic within the present context, it is supported only by the revelations that repeat the legacy of real history: that

the impact of COVID-19 on racial and social disparities (see, for example, Greenaway et al., 2020; Nafilyan et al., 2021; Van Dyke et al., 2021); or that the line between legislation to prevent the spread of the virus and the curtailing of civil rights and protests is often difficult to discern. Indeed, if the 'reducing the stupid' that was promised turns out to be what Vattimo and Zabala describe as 'nothing else than the "silencing" of other interlocutors through an apparent dialogue', then 'truth and violence will become interchangeable' (2011, p.19).

It's a pandemic, stupid

These are all big issues to pass over so quickly. My suggestion here is merely that these echoes of the colonial seem to order the significant from the insignificant of an interpretative horizon, at a time when making that judgement is increasingly difficult. Furthermore, the difficulty of making this judgement is rooted in part in the inevitable link between the politics of health (how to deal with the pandemic) and the politics of expertise (how to deal with post-truth, alternative facts and fake news); as well as in part a consequence of attempting to think through immunology in the context of public health, when, as Han suggested, immunology is no longer the appropriate modality for understanding a late-capitalist 'achievement society' of digital communication networks.

But what do we do when confronted with genuine ignorance or misdirected understanding – be this a person travelling too far from their home, a patient refusing a vaccine or a protester outside of a clinic warning of global conspiracies? The answer is clearly not found in the imperative for people to simply make their own minds up (or 'do your own research!' as below-the-line comments so frequently call for). This would merely continue the models of possession and choice lying at the heart of the traditional disdain for ignorance, which we have already called into question. Likewise, any banal recourse to liberal rights

('everyone has the right to an opinion,' etc.) or arguments about negative freedom ('who are we to call another person stupid?') should be dismissed, because rights are not the ethical problem at hand. Nor would this answer address the obvious *need* for speed and urgency in public health responses to the pandemic. I take as granted that in such times, collective and unified responses by a population are more effective and preferable. The risk, though, is that a binary model of knowledge as possession overlooks the production of knowledge, *not* in terms of interpreting the 'evidence' or 'data' (which is where COVID conspiracies speak at odds with government advisers using the same language), but rather in terms of the flow and circulation of interpretation at work in any form of understanding.

This is the nub of the issue. When deployed in public health debates, it becomes clear that the accusation of stupidity carries an interpretative commitment by academics, intellectuals, public commentators and the interested public that goes beyond a simple identification of lack of knowledge. Instead it becomes a key trope for maintaining certain economies of practice which are, in turn, embedded within a range of contexts that can and should be questioned. Paul and Haddad thus rightly note that dismissing (or ignoring) ignorance can be significant. 'A merely defensive move animated by the desire to restore the shattered fabric of science and policy is...*not enough*' (2019, p.300, my emphasis). Instead, attempting to reconstruct the hermeneutic horizons in play can bring into focus the ways in which this trope moves so easily through matters of applied health to wider political and epistemological concerns.

In this sense, it is perfectly reasonable to accept that accusations of stupidity are effectively throwaway insults, and that the study of memes and online debates are perhaps the least significant concerns in the current global health situation. My argument is simply that what is considered insignificant in one's horizon – whether this be social psychologists using students in

experiments, the ways in which immunological models support approaches to epistemology, or the uncomfortable resonances with past cultural practices of domination – can yet be telling, *precisely* because of their insignificance. This, of course, would not just be limited to epidemics. When we talk about COVID-19 shining a light on particular tensions within the production of knowledge and the circulation of information, such a light should also pick up the continuum this sits on: which includes discursive sites around climate change, the existence of Extra Terrestrials and the sighting of UFOs, the hidden covens of the global elite, the local covens of New Age cults, and so on. From the most frivolous to the most serious, such a continuum highlights that the deployment of stupidity is not simply an issue regarding the existence of or psychology behind 'ignorance'; nor is it, conversely, the snobbishness of intellectuals pouring scorn on them. Rather, it suggests a set of interrelationships between tropes and reasoning, critique and conspiracy, carried within the banal and insignificant aspects often overlooked in the act of declaring one thing or another 'stupid'.

If these insignificances are what are passed over in silence when stupidity is invoked, then engaging with them may offer alternative ways to speak about the experience of an immunological struggle in an achievement society. And this, I think, is an issue: when we insist on the primacy of knowledge as a possessed determinant of morality, what we lack is a way of speaking which falls in between knowing and not-knowing. Not quite Han's idiot, but more a way of articulating experiences within and beyond the pandemic which are not as easy to categorise as 'other' or 'alienated' along the traditional immunological models of society. This would be to interpret what one might fear in a vaccine, or how one may feel about distance from loved ones, when the pandemic has inflicted an excess of *same-ness*: from the dreary repetition of lockdown to the same public health problems and socio-cultural inequalities.

It would also involve the mindfulness of what broader structures and politics of meaning – and their effective histories – are invoked when insisting, through a throwaway meme or in-depth research paper, on the completion of knowledge, the triumph of achievement or the certainty of what stupidity is.

Chapter 3

Zombified Intelligence in The Knowledge Society

Zombies are one of the oldest cultural sites for representing fear and terror, or what Todd Platts calls 'bureaucratically managed representations of cultural anxiety' (2013, p.548). There are three key aspects to this anxiety. First, zombification inflicts a loss of personal autonomy to the base desires of a crowd. Second, zombie outbreaks show the fragility of civilised society in the face of unthinking violence. Third, the standard trope of zombies emerging from botched scientific or medical experiments reflect a long-standing concern of what happens when knowledge is used to the wrong ends, or falls into the wrong hands. This is why, while the zombie trope may be relatively recent in the Western imaginary, it is a direct continuation of the longer-standing concerns of the demonic impersonation of truth. More than just a monstrous devil, the demon of the European tradition is first and foremost an impersonator: they allow the dead to walk, which in turn discredits the significance and singularity of the Christian resurrection story. As such, this simulation is not simply inauthentic – the zombie is a human incapable of human thought – but also undermines the very facticity of the authentic (Klossowski, 2007, p.18). It is this theme which continues in modern zombie media when outbreaks are linked to the pursuit of knowledge.

As a result, it is not surprising that the rise of the stupid as a commonplace in the era of 'post-truth' has prompted the zombie trope – and its accompanying cultural anxiety – to turn to politics. Commenting on the rise of zombie movies in the late 2000s, David Sirota remarks: 'If zombies specifically represent the apocalyptic downsides of immortalized mindlessness,

then today's zombie zeitgeist is not merely a result of scary quandaries created by stupidity. It is a reaction to both those problems and the sense that they can never be thwarted' (Sirota 2009). Tyler Malone uses Romero's *Dawn of the Dead* as an analogy for post-Fordism where 'true hell isn't a dance with the devil, but continuous mindless consumption, long after the joy of the indulgence has left us' (Malone, 2018). Online magazine Datacide warns of the 'zombie culture' at the heart of neoliberalism, watched over by 'vampire management' ('they want your intelligence, your psychic energies' (Karloff, ND)). Henry Giroux writes of a 'zombie politics' spreading throughout culture ('the living dead rule and rail against any institution, set of values, and social relations that embrace the common good or exhibit compassion for the suffering of others' (2019, p.2)). Paul Krugman (2020) calls 'zombie ideas' a set of economic notions which should have died a long time ago but are kept alive by modern conservatism and propped up by right-wing billionaires (taxing high earners stifles the economy, universal healthcare is impossible, and so on). And so on.

The range of uses of the zombie across these cases demonstrates what an enticing trope it is. It stitches together the long-time fears of the living dead and mindless violence, with both the post-industrial currency of information and intelligence, and the twitch-trigger of First-Person Shooter (FPS) video games. Who would not be appalled by the zombification of mass culture, the perpetuation and encouragement of the mindless masses, the banal yet 'complex process of manipulation at the level of symbols and aims at implanting specific forms of ideology into zombie minds, to ensure that they think and act in accordance with the dictates of zombie culture' (Datacide, ND)? A stupidity enacting life, which is opposed to all that makes life liveable?

Unfortunately, these kinds of invocations of zombies often end up settling on the more obvious aspects of both cultural tradition and gaming enjoyment. As a result, however much

the specific problems of twenty-first century late capitalism and the so-called 'knowledge society' can be imprinted on a zombie form, the rhetorical structure of such a form remains generally the same across any modern period: zombies embody the anxiety of contamination, and the horror of traversing the limits of life as we want it. Zombie stories are, in this sense, the ultimate trope of immunological anxiety; the enjoyment of zombies is instead a permanently suspended mode of what Rehak refers to as the 'prison of presence' found in FPS games, when 'embodied vulnerability *(they're coming for me!)* deliciously complemented its violent agency *(take that, you bastard!)*' (2007, p.140). However much we fire into the horde, they will still be there the next time we load up the game.

In contrast, Kevin Eastman and Carlos Gallardo's 2018 film *Redcon-1*, Zach Snyder's 2021 *Army of the Dead* and Paul Hoen's 2018 *Zombies* franchise can all be viewed as examples of a different contemporary anxiety whereby the traditional cognitive divide between the undead and the living is called into question. While the title of *Redcon-1* would not be out of place in a 1980s action-adventure film, it is drawn from the US Army Field Manual where it stands for the highest state of Readiness Condition. However, the action takes place not in the US, or one of the myriad of unnamed South American states one might expect, but instead in the bog-standard streets of south-east England. A virus has infected large swathes of the UK's population, turning them into zombies. A joint task force of American and British soldiers is sent into a dangerous area in order to extract a scientist who may have the cure. The clichés are set from the beginning: the squad could well be the same in *Aliens*, *Resident Evil* or *Doom*. The set pieces arrive at the expected times, and the team is killed one by one in time-honoured fashion. In other words, much is done to invest the audience's trust in the familiarity of this particular form of apocalypse. But if the film is about Readiness Condition, then

what is this readiness *for*? Given that every other aspect of the film makes copious use of existing tropes, there remains only one possible candidate. The zombies have retained, in many cases, certain degrees of rationality. This is manifested in the learned rituals of their working life: as the squad moves through a dangerous neighbourhood, they see a zombie postman doing his rounds; they see zombies 'communicating' with each other, and some are even watching pornography. In *Army of the Dead* (incidentally, the original subtitle for *Redcon-1*), Las Vegas has been walled up with a zombie population inside following the traditional infectious outbreak, while refugees are kept in camps around the city. The zombies, it turns out, have several stages of cognitive development, and those with degrees of agency (the 'Alphas') are able to organise the others into a primitivist society where life is – or, technically, was – nasty, brutish and short. A group of specialists are sent to retrieve $200m from a casino vault before Vegas is hit by a nuclear strike. Despite their sacrificial offerings to the zombie leader Zeus, their murder of his Queen leads to a strategic assault by the Alphas on the casino. Taking on a completely different genre, Hoen's musicals *Zombies* and *Zombies 2* centre on a town in the aftermath of a power plant explosion, which has inexplicably turned half of the population into flesh-eaters. While they are now controlled with electronic bracelets that limit their aggression, nevertheless a barricade separates the two sides of the town: the educated and well-presented humans on one side, and the zombies in slums and lack of educational opportunities on the other. When a zombie and a cheerleader engage in a *Romeo and Juliet*-esque romance, they challenge both the prejudices of humans and the bomb-making revolutionaries of the zombies.

If zombies are a site for representing fear and terror, then, it is possible to detect a common contemporary anxiety across all of these otherwise unrelated films: what if the stupid were

no longer a ready-to-hand group to which there is no reason to seriously attend, and instead an active, dangerous force inflicting real social, economic and political damage? Not simply passive imbeciles, in the Kantian sense, but capable of limited cognition, producing a highly active but ultimately hollow and nihilistic group threatening to overwhelm the core values of decent politics? A force of, to quote the subtitle of Robert Wuthnow's book *The Left Behind*, 'decline and rage', which, in the longer history of the demonic, undermines the facticity of authentic politics? How can such a group be reconciled with the narratives of heroism in the face of political adversity?

The dangerously stupid and how to find them

Such questions are not just for zombie films, of course. The alignment of stupidity with danger can be found in traditions of thought that include Karl Popper, Hannah Arendt, Dietrich Boenhoffer, and many more. In his encyclopaedic *Natural History of Stupidity*, Paul Tabori declares that stupidity 'is like a black sun, spreading death instead of life, blighting instead of fructifying, destroying instead of creating. Its manifestations are legion, its symptoms endless' (1993, p.9); 'stupidity is Man's deadliest weapon, his most devastating epidemic' (p.12).

This weaponisation of stupidity has been honed sharply in the discourses surrounding the UK Referendum on leaving the European Union. Shortly before the referendum took place, the President of the European Council, Donald Tusk, warned British Prime Minister David Cameron that the whole undertaking would be 'dangerous and stupid'. For those on the Remain side, it turned out worse. For them, the undertaking unleashed the forces of a particular breed on to political decision-making: the forces of the *dangerously stupid*. What made the stupid dangerous was not their ignorance, so much as their combination of simmering anger and the ability to misuse information. What seemed so aggravating to their political opponents was the

imitation of the processes of intelligence – drawing on evidence bases, applying logical sequencing to claims and so on – but mutating these processes into belligerent claims that seemed to bear no relation to established facts, though much to hearsay. The danger of this stupidity was its impersonation of expertise, its reduction of complexity to carelessness, and the translation of all of this into a readymade and socially acceptable fury. 'Brexit is not only characterised by nakedly evident stupidity,' Lyndsey Stonebridge wrote in *Prospect*, 'Its thoughtlessness is banal.'

As with a zombie horde, the problem was not identifying this *force majeure*, as this was not only easy but could even be quite entertaining: for example, when a group of hard-line Leave voters attempted to burn a European Union flag to mark 'Brexit Day', but failed to light it due to EU safety regulations ensuring all flags are fire-retardant (Jolly 2020). It was rather a question of what resources – culturally, theoretically and practically – there were to combat it, when the well-rehearsed tactical procedures had little effect.

In this light, it is difficult not to watch *Redcon-1* in terms of the confusion and weariness of the post-Brexit landscape; particularly for those who voted to remain. Scenes of highly trained elite troopers, confident in their skills and expertise, looking on in fear as the UK population in all of their mundane and everyday roles develop seething and violent rage, seems pertinent to the helpless frustration of those who saw Brexit as a mistake, propagated by lies and misinformation. When former Finnish Prime Minister Alex Stubb described Brexit as 'completely senseless in the modern world', his words may well not only refer to economic strategies at state level, but also to the mystery of how the referendum had turned out the way it had. Attempts to solve the mystery – of which there were many – continuously returned to the idea of Brexit as a battlefield where rationality and expertise were pitted against cognitive

dissonance and blind rage, the archetypal conflict of post-truth. It was not a vote but an act of frustration, many pundits argued, a venting of pent-up anger. Tim Houghton suggested that Brexit happened simply because 'the Leave side used the alluring slogan ['Take Back Control'] repeatedly and relentlessly whereas the Remain side never coined a simple and affective slogan' (2016). Stories of Facebook manipulation by Cambridge Analytica served to cement this curiously passive-aggressive voting base, a base deemed to possess only two capacities: mindlessly following soundbites and equally mindlessly fighting those who were different to them. After YouGov published findings suggesting that 70 per cent of voters with GCSE or lower academic qualifications voted for Brexit, while 68 per cent of those with a degree or higher voted for Remain, the deal was sealed for those seeking to resolve the mystery; and sealed far quicker than any withdrawal agreements ever could be. This was not an ill-judged decision by a cognitariat; it was a species condition. 'Millions Infected. A Nation Divided. An Enemy with No Soul,' as *Redcon-1*'s tagline ran.

Of course, I'm not saying that *Redcon-1* is simply a crude metaphor for Brexit. David Graeber rightly argues that, 'pop culture does not exist in order to convince anyone of anything. It exists for the sake of pleasure. Still,' he continues, 'if you pay close attention, one will also observe that most pop culture projects do also tend to make that very pleasure into a kind of argument' (2015, p.212), As such, there *are* metaphors at work, just as the 'aftereffects of war, terrorism, and natural disasters so closely resemble the scenarios of zombie cinema' (Bishop, 2009, p.18), every zombie film possesses some form of suggestion of social commentary. *Army of the Dead* provides clunky but timely analogies for both the COVID-19 pandemic lockdowns, and the 2021 storming of Capitol Hill by protesters wanting to overturn the presidential election results. The poster boy of the Capitol Hill riot, the 'QAnon Shaman' Jake Angeli, is certainly no

Zeus, but they share the same animistic tropes, the same threat of decadent primitivism which led David Roberts (2017) to describe Trump's followers as enacting a 'tribal epistemology'. (Not, it should be noted, the tribal epistemologies from around the world gathered in Helmut Wautischer's excellent collection on the philosophy of anthropology; but rather a situation when 'information is evaluated based not on conformity to common standards of evidence or correspondence to a common understanding of the world, but on whether it supports the tribe's values and goals and is vouchsafed by tribal leaders'. Primitives, in other words; echoing Robert Musil's 1933 treatise on fascism, 'The Ruminations of a Slow-Witted Mind'). Once a wall is built around Las Vegas, the zombies literally become the 'left behind'; that rather-too-useful term discovered in post-Trump and post-Brexit political discourse (though originally found in the apocalyptic theology of premillennial dispensationalism, a minority Christian interpretation of the end times, and given new life by a 2014 film starring Nicholas Cage). *Zombies*, meanwhile, is replete with references to 1950s segregation and Cold War conflicts: zombie students are barred from taking classes with their human peers based on assumptions about their lack of intellect, and schools are fitted out with 'Z bunkers' in case of invasion.

Whether or not such metaphors were intended, or map closely to the threats to public discourse, is less significant than how each film *resolves* its narrative. To begin, each establishes a spatial territorialisation: areas containing zombies are quarantined by physical walls, and within them quasi-societies are formed, the incarnation of the zombie society that the likes of Malone, Giroux and Krugman would find familiar. In *Redcon-1*, the infection zone is initially a kind of mindless simulation of everyday life in a drab town, gradually replaced by an alternative organisation of military corps (who, by the end of the film, have largely displaced all their earlier porn-

watching brethren). *Army of the Dead*'s Las Vegas becomes a rendition of Hobbes' *Leviathon*, where amid a state of nature the zombies' cognitive functions allow them to become organised, marking out territories and conducting animist-esque rituals. *Zombies* presents an oppressed underclass, forced to undertake industrial and menial jobs, living in squalor and required to wear jumpsuits.

But what strikes me about these different representations of zombified intelligence is that the same problem occurs in all of them. At the end of each film, there is a form of reterritorialisation, providing the narrative resolution. Once *Redcon-1* reveals some zombies have formed a military group (by virtue of being the most ritualised members of the population, they retain their training completely), it becomes a standard war film; the zombie soldiers even wear hazmat suits to hide their original undead features. *Army of the Dead* forgets the ritualistic society of zombies to showcase Dave Bautista's heroism. *Zombies* concludes that the real enemy is prejudice, anger and pride; once these are defeated, everyone is revealed to be much the same. These narrative conclusions all enact the overcoming of a fundamental *distance* or *difference* between the human and the zombie. Of course, the initial presentation of the intelligent zombie was troubling precisely *because* of its similarity and connection to normal human behaviour, not its differences. As such, the new territorialising only works by ignoring the basic tenets of the zombie intelligence that were previously established. The original premise is sacrificed for a somewhat neater and tidier account of how to discern good from bad. And this, I think, warrants a closer look, because the persuasiveness (or lack thereof) of such narrative resolutions resonates with the wider problem of the dangerously stupid.

Resolution, or making truth matter again
This resonance can be seen in the form of diagnosis that

each resolution makes to relieve the anxieties of zombified intelligence. If the anxiety is rooted in a gathering together of ritualised people abiding by a conspiratorial megalomaniac – a 'crowd', in Le Bon's sense, but capable of far more ruthless military organisation – then the answer is to expose the conspiracy and aim for the gaps in their organisational logic. Alternatively, if the fear is a return to the pre-Enlightened embracing of mythical figures rather than rational choice, then Roberts' account of tribal epistemology provides a clear antidote, where the danger of stupidity is framed as a mutated figure from civilised society's past (or, more precisely, an imagining of society's past). If the danger is simply the problem of not talking to each other, the solution is obviously for us all to see past each other's decaying skin and re-establish trust and dialogue. This is what Lee McIntyre seems to suggest in his book *How to Talk to a Science Denier*, where he suggests that while using facts and exposing techniques of reasoning can be effective against stupidity – '*anyone* can fight back against science deniers!' – changing the minds of those deeply committed to fallacious reasoning requires more dialogical engagement based on the establishment of a trusting relationship. Indeed, McIntyre refers to this process of presenting science-deniers with facts from an expert as 'inoculation' (2021, p.xiii).

Roberts and McIntyre will both write of *making the truth matter* in terms of re-connecting a lost relationship between the ignorant and the intelligent. This distance-bridging is the ground for their approaches: rather than re-assert the authority of fact in the face of this mutation of knowledge, Roberts notes that 'facts do not, contra common belief, speak for themselves. Accuracy doesn't matter unless there are institutions and norms with the authority to make it matter. The question for the press is how to make truth matter *again*' (Roberts, 2017, my emphasis). This reference to 'again' is both a play on Trump's MAGA slogan, and the invoking of a

past with no – or at least less – structural severance between 'the truth' and 'mattering'.

This 'again' is a key aspect of the rhetorical structure used by recent literature concerned with the dangers of stupidity, and its use of memory is particularly interesting. First, making truth matter again produces a gap, a fracture in the progress of knowledge and/or civilisation (the truth that was once there has been lost). Second, it closes that gap, in order to subdue its threat to the progress of knowledge and/or civilisation (what matters about truth is identified). Third, it forgets the gap by insisting on the continual presence of knowledge and/or civilisation all along (truth has always mattered, and has always been here). The fracture is closed as soon as one accepts that truth does, in fact, matter; but given that the fracture is premised on the memory of what once mattered, it is never really a fracture.

If these narrative resolutions work by insisting on the existence of a severance between what is true and what matters, this move simultaneously obscures any view of what such a distance or loss looks like *outside of* the perspective of the final 'truth'. This, in many ways, constitutes the 'other-ness' of the dangerously stupid. Hence, McIntyre writes of the need to understand the science denier, but his narratives of visiting Flat Earth conventions and so on tend to consist of him observing how wrong everyone there is. The reconnection between truth and its mattering is not performed in the dialogues between McIntyre and Flat Earthers, but rather in the interpretative relationship between McIntyre and his readers. Even in Matthew D'Ancona's critique of post-truth (2017), that specifically claims it is 'not a restorationalist or heritage project' because clearly a 'past of untarnished veracity' never existed, there is nevertheless the argument that we should learn to trust again in Enlightenment liberal values. Despite his protestations, D'Ancona's approach insists, at the very least, on the restoration of a *concern* for truth (Vogelmann 2018, p.21).

The point is not that Flat Earthers are in some way not wrong, any more than zombies are not dangerous. The point is rather, as Cynthia Townley argues, that in 'almost all epistemologies, ignorance is understood simply to be the absence of knowledge or information, and the fact that this ignorance generates an imperative to remedy that lack' (2006, pp.37-8). Such an absence is not only a neutral quantifier (lacking enough knowledge of x, needing to know more about y), but *also* a rhetorical fortification of the epistemologies proposed to remedy it. A lack of knowledge makes knowledge important. However, this insistence on a lack or loss can lead to what Avital Ronell describes as the 'fantasy' of the denunciation of stupidity; a task Ronell sees being taken on by the intellectual to 'ceaselessly expose that which is stupid or has failed in understanding'. In doing so, exposition involves a colonising of absent space: '[l]ocating the space of stupidity has been part of a repertoire binding any intelligent – or, finally, stupid – activity that seeks to establish itself and *territorialize* its findings' (2002, p.37, my emphasis). It is not surprising, then, that each resolution to the dangerously stupid involves an insistence on a particular form of spatial territory that distinguishes the zombie from the human, or the stupid from the non-stupid, linked together by a narrative progression built at least in part on the curious nostalgia of the 'again'.

What is so wrong with this? Nothing – indeed, it reflects in many ways what Claire Colebrook describes as a standard intellectual practice of 'chronological repetition' whereby a writer separates their work from their predecessors by framing them 'through the recognition of a blindness, error or misinterpretation, which the current author can then remedy'. (2009, p.47) This is, after all, exactly what I'm about to do.

I think the issue becomes more complicated under three conditions, and such conditions are prevalent in the current cultural climate. First, if the territorialising motif that allows the difference between stupid and non-stupid to be articulated

49

rhetorically becomes problematic; second, if this means that, in order to be effective, such a rhetoric instead needs to go *beyond* a mere lack, difference, or inversion of knowledge in the form Townley describes; and third, if the lack of knowledge being expressed is embedded within a more general nostalgia, and this nostalgia supersedes the epistemological value of the expression. All three trouble the persuasiveness of the *'again'* at work in the resolution of dangerous stupidity. In doing so, they highlight certain interpretative conditions that underlie the anxieties about the intelligent zombie.

The knowledge society

Let's begin with the motif of territorialising. As previously noted, *Army of the Dead* frames its Alpha zombies within a quasi-Hobbesian state of nature. This is, obviously, not simply an anthropological projection of what happens when the human form gives in to violent lawlessness and cannibalistic aggression; any more than Hobbes' account of the state of nature in the seventeenth century was. In fact, the very persuasiveness of Hobbes' argument of the need for societal agreement is rooted in slippages between metaphors, analogies and experienced reality. This is no better illustrated than when what was effectively a thought experiment coincided with European expansion into the 'New World', where colonists encountered 'natives' who appeared, largely due to their ignorance of European farming methods, to be enacting the very state Hobbes had described. In this way, and to different ends, both Hobbes and Zach Snyder have assembled a set of relations in order to pull together contemporary anxieties of violence and the loss of culture with universalistic concerns around reason, intellect and right. Both find their experiments in pre- and post-society reified within broader narratives, whether this be European colonial conquest or vigilante riots.

The difference is that in Hobbes' time the issue really *was*

spatial territory. Today, territorialisation is superseded by the fundamental precarity of what Franco 'Bifo' Berardi describes as 'the knowledge society' of late capitalism. For Berardi, this precarity refers 'to the fragmentation of time and the unceasing deterritorialization of the factors of social production' (Berardi 2012, p.117). This is rooted in the shift to the post-industrial knowledge society in the late 60s and 70s, a shift marked by 'technological transformations' which 'displaced the focus from the sphere of the production of material goods towards the sphere of semiotic goods: the info-sphere' (2009b, p.44). Capitalism in its historical sense, as the production and exchange of material goods, was replaced with semio-capitalism, the production and exchange of signs. Under such conditions:

Both labor and capital…no longer have a stable relation to territory or community. Capital flows in the financial circuits, and enterprise is no longer based on territorialised material assets, but on signs, ideas, information, knowledge, and linguistic exchange. Enterprise is no longer linked to territory and the work process is no longer based on a community of workers…but instead takes the form of an ever-changing recombination of time fragments connected in the global network. (Berardi 2012, pp.117-18)

If Snyder's film makes much of the difference between the high-tech capabilities of the global world outside Las Vegas and the mythological primitives within, this serves to emphasise the anomaly of focusing on the dangerously stupid as a spatialised, bounded group at precisely the time that the basis of such a grouping is based on the ever-changing recombination of 'signs, ideas, information, knowledge and linguistic exchange' rather than the solidity of, say, a fixed community. Consider, for example, the hybrid monstrosity created from mass data collection embedded within information technology, storing

the extensive contents of our lives, mutated into simplistic collectives. After Brexit, this meant both *ad hominem* stereotypes – '[c]onvinced that they were right, Remainers were very much inclined to regard people who voted Leave as being old, white, under-educated stupid and racist' (Mills, 2019, p.73) – and newfound populations such as the often-discussed 'left behind'. This latter group emerged as a shorthand for some kind of primitive instinct-response by those incapable of strategic thought; a shorthand that, as Rafael Behr noted, 'resonates as an analysis of social and political trends' but 'has become a convenient affliction projected on to diverse voters by politicians who need simple answers to complex questions' (Behr, 2017). The left behind worked as a group because it drew on the territorialised distance between not only the economically downtrodden and the well-off, but also the inarticulate and the writers and policymakers looking for decisive answers to how Brexit happened. When Guy Standing (2018) warned that the 'notion of "left behind" implies a static situation, which is misleading', this is not just in an economic sense, but also in the way that the sense-making cynicism of post-Brexit analysis established itself in terms of intellectual territory: territories which no longer reflect the circulation of information and enterprise, but are nevertheless formed through particular figures and motifs with a longer culture resonance.

Such figures are not limited to the zombie, the racist or the socially and economically alienated. If the flow of capital creates complexities in the traditional groups of economic and social grouping, then the models of the intellectual expert are not exempt from this. Indeed, under the conditions of semio-capitalism, the intellect becomes *the* key commodity: the shift to immaterial ideas, signs and knowledge creates a tension between the ideal figure of critical knowledge who spreads truth freely and universally, and the guardian of intellectual property who prevents the circulation of knowledge in order to

retain its value.

However, rhetorically speaking the latter still depends on the former. As Berardi argues, the view of intellectual activity within the economy – such as in Marx's discussion of the 'general intellect' in the *Grundrisse* – is that which can separate itself as independent from social conditions. 'As the bearer of a universal human rationality, the enlightened intellectual can be considered as the social determination of Kant's "I think". The intellectual is the guarantor of a thought freed from any boundaries, the expression of a universally human rationality' (Berardi 2009a, p.30). This form of enlightenment required a space ostensibly outside of social conditions, such as the traditional model of the university (Fisher, 2021, p.132). To observe the problem of sustaining such a model, one need only think of how every year the media produces stories about academic grades getting easier or harder and university entries rising or falling (given they will never stay the same, this is a perpetual motion machine of journalism), along with the usual scoffing about 'dumbing down' and 'joke degrees'. But in many cases, what are described as 'joke' or 'unnecessary' degrees are the product of years of struggle for professional recognition, such as in childcare, nursing or social work. They are, in effect, a testament to the currency of intelligence – or, at least, *signifiers* of intelligence, such as accredited degrees – in the development of late-capitalist economies. Boaventura de Sousa Santos thus refers to this as 'university capitalism': the production of 'a commodity whose market value derives from its capacity to create other market values' (2018, p.272). At the same time, the vocational nature of such degrees means that the expansion of the general intellect sits in tension between, on the one hand, the enhanced cognitive training of higher degrees, and on the other hand a quagmire of professional learning outcomes which replace the 'universally human rationality' Kant may have envisaged.

Experts in danger

Under such conditions, the Kantian notion of an intellectual engaged in universal causes of truth and value beyond functionality not only becomes anachronistic – for 'once scientists become workers applied to the machine of cognitive production, and poets workers applied to advertising, the machine of imaginative production, there is no universal function to be fulfilled anymore' (Berardi, 2009a, p.33) – but also regains its value in the rhetorical placeholder of 'the expert'. Indeed, this idea was captured as far back as 1965, when Daniel Greenberg conducted an interview in *Science* with a fictional Dr Grant Swinger. Greenberg created Swinger as the director of the 'Breakthrough Institute', whose sole role was to provide breath-taking scientific innovations on public demand. Half a century later, Steven Ward describes the university's fate within the knowledge society without Greenberg's irony:

> Knowledge society proponents envision universities as engines of economic growth…They are to do this by providing the new epistemic materials for post-industrial production, by becoming the setting for entrepreneurial innovation, business incubation and technology transfer and by providing a well-trained and flexible labor force that can continuously be retrained with useful skills as economic conditions and the needs of corporations change. (Ward, 2012, p.131)

This does not mean, of course, that *all* knowledge is commodified and thinking is eternally subject to the machinery of university capitalism, as some form of hyperreal determinism. Instead, it acknowledges that the territories of intellectual provenance are less organismic or geographic, despite remaining wrapped in the Kant/Swinger figure of the expert, and more of an assemblage of literacies, localised inventions, aspects of intellectual property

54

legalities, publishing contracts, organisations of time, and so on. If nothing else, it points to why the figure of truth may be a nostalgic one.

This is something that Bruno Latour highlights at the start of his *Inquiry into Modes of Existence*. Latour describes a conference between industrialists and climate scientists, where one of the former asks one of the latter why they should believe *them* – their scientific data, their methods, their findings showing the impact of industry on the climate – above anybody else. The industrialist's question is, in many ways, the ultimate expression of the dangers of a 'post-truth' age that is not based on ignorance as lack, but a mutation of knowledge – why *your* truth, and not *mine*? For McIntyre, the biggest problem of post-truth is not just that 'feelings outweigh evidence, and ideology is ascendant' (2021, p.xi), but the reign of misinformation; that is, placing spurious claims within the performance of 'fact', something that McIntyre has elsewhere studiously linked back to the influence of industry on the public communication of science (McIntyre, 2018). But in Latour's case, he is surprised to find the climate professor does not simply refer to facts, or to the authority of science. Instead, he talks of the need to trust in its *institutions*. This trust involves acknowledging the fragility of such institutions, 'encumbered with terribly material and mundane elements' like peer review, financial constraint, employment contracts, accidental typos, and so on.

Latour notes that, while the scientist's defence seems to be like a priest justifying the existence of God by sketching out 'the organisational chart of the Vatican, the bureaucratic history of the Councils, and the countless glosses on treatises of canon law' (2013, p.4), it is nevertheless a far better strategy for engaging with these kinds of challenges to knowledge. This is because, Latour argues, the authority of institutions has little in the way of sustainable defence mechanisms once they are called into question: they are not *designed to be challenged*.

(It is not surprising, then, that Frieder Vogelmann finds the problems with how 'those diagnosing a "post-truth era"' like McIntyre 'ironically replace justification with the call to trust again in the authority of science', and, furthermore, 'the science we are called to trust again is conceptualized as a homogenous enterprise with a history of linear progress' (2019, p.7)).

In other words, remedying the lack of knowledge by an insistent repetition of, or return to, what has been lost overlooks the vulnerabilities of knowledge that constitute necessary elements of its production. This is what is obscured in the 'again' of 'making truth matter again', when the gap being bridged is precisely those contingent aspects involved in the production of knowledge. It is also the rhetorical power of the 'again', because what is being returned is typically a revitalised figure of universal knowledge invoked to purposefully sit outside of the messy tedium of contemporary knowledge creation.

This is why, when the UK Education Minister Michael Gove infamously claimed during the referendum campaign that the public 'have had enough of experts', the academic backlash was largely predictable; it took the shape of a re-assertion of the importance of expertise, by virtue of appeal to experts. Yet, for all that Gove became an icon of anti-intellectualism in the Brexit campaign, few of these responses really addressed the actual point he had made (Grimwood, 2021, p.167). They neither defended experts with reasons that an angry cynic might trust, nor noted that Gove was targeting a particular figure of the expert – 'from organizations with acronyms that have got things so wrong in the past', he later tried to clarify – rather than the notion of expertise in itself. In other words, it was the positioning of the expert (a particular figure or role) as unchallengeable, without attending to the ways in which this position was established (the social practice of intelligence – or, on Latour's terms, the relational networks of 'attachment, precaution, entanglement, dependence and care' (2008, p.2))

which Gove was, apparently, trying to draw attention to.

Basing the rhetorical fortification of epistemic authority on the lack of knowledge, or the gap between the world-as-it-is and the world-as-it-should-be-known, thus encounters problems when it is deployed to address the social anxieties embedded within the knowledge society of semio-capitalism. If, as Berardi argues, there is no universal function of intelligence demanded by society, then its role can be rediscovered in the act of unmasking this very fact: demonstrating the fundamental alienation of everyday practices with underlying reality. Up until the late 1960s and 1970s, the problem regarding the distribution of knowledge and the education of the masses was *alienation*, or the 'relational discomfort' of 'incommunicability' (Berardi, 2009a, p.30). In the Fordist economy, workers couldn't talk to each other: the machines were too loud, and the social and geographical distinction of the classes too rigid. In wider society, universities could not be accessed by the majority of the people. There was no way – or so the intellectuals, particularly of a Marxist disposition, argued – to understand the dangers of such a society other than for the universal intellect to identify it.

But in the knowledge society, alienation is replaced with *saturation*. 'Not silence, but uninterrupted noise, not Antonioni's red desert, but a cognitive space overloaded with nervous incentives to act: this is the alienation of our times' (Berardi, 2011, p.108). In this sense, alienation no longer exists as a form of fetishized detachment from the fruits of one's labour, in the traditional Marxist account, but rather as a form of overloaded 'de-realization'; 'a feeling of anguish and frustration related to the inaccessible body of the other, to the dis-tonic feelings of a non-sympathetic organism incapable of living a happy relation with otherness and therefore with itself' (2009a, pp.108-9). This saturated field of communication is, for Han, one problem with social theories that have insisted on using immunological models to describe culture and society; the same immunology

that, as we have seen, distinguishes the stupid from the non-stupid. Indeed, he points out that Orwell's account of the dystoptian state that controls language, however popular a reference point it may remain, is fundamentally wrong precisely because 'today's society of information is not characterised by destroying words, but by multiplying them without end' (Han, 2017, p.37).

Nostalgic zombies

We are left, then, with a problematic contradiction with the dangerously stupid. The sensibility of danger, fear or anxiety around the activities of a post-truth or anti-intellectual force sits ill-at-ease with many of the immediate attempts to conceptualise them, which seem to depend on a nostalgic invocation of the intellect; an intellect not dispossessed by the stupid but, in many senses, by the very vehicles of their own production. Indeed, it seems to me that the defences of intelligence often turn out to be an assertion or insistence on the *actual living existence* of the intellectual; whether through gatekeeping, barrier-creation or acts of anachronistic remembrance, not just for the heady days of intellectual freedom, but for the cliché of the intellectual hero which permeates the knowledge society as a kind of totemic signifier.

In this sense, I am reminded of Jean Baudrillard's critique of Foucault's work on power; it offered a perfect explanation and analysis, Baudrillard acknowledged, but such a perfect analysis could only take the place of something which is already dead. One can speak about power so much, and see it everywhere, precisely because it 'can no longer be found...if one speaks about it so much and so well, that's because it is deceased, a ghost, a puppet; such is also the meaning of Kafka's words: the Messiah of the day after is only a God resuscitated from among the dead, a zombie' (Baudrillard 1977 [2007], p.64).

What, then, is the danger of these zombies? From the moment

Army of the Dead begins, the audience will have a good idea of what is going to happen: from the daring heist team's selection process to the suspicious corporate ex-military representative who accompanies them, the bully of a refugee camp guard who also tags along only to be sacrificed. We know as soon as the team enters Las Vegas that only one or two will make it out alive. We suspect there will be an act of heroic sacrifice, where a main character understands the situation beyond their own instincts or wants. And we are correct in all of this. Indeed, the only original twist is when the protagonists discover the bodies of a previous team sent on the same mission. At this point, the film presents us not with mere clichés, but with a potentially endless loop: a realisation that countless numbers of 'heroes' have come before our protagonists and will come after them should they fail. Instead of accepting this conclusion, however, the protagonists revert to the traditional response to zombie hordes – *do something different!* (Or at least be a bit better, a bit more heroic than the unnamed soldiers of the past...) It is here in the film, tellingly, that the collective rationality of the zombies ceases to be shown, while the Alpha leader becomes a monster of mythical proportions.

The *Zombies* franchise, meanwhile, positively revels in its bricolage of references to its predecessors, a celebration of its lack of originality and its overt embracing of the camp. A film centred on cheerleading, the luminous pinks of its colour palette recalls Jamie Babbit's 1999 film about gay conversion therapy, *But I'm a Cheerleader*. The zombies' revolutionary fervour is stoked by call-backs to the Broadway musical *Hamilton*; the depth of romance is achieved simply by referencing *High School Musical* set designs and props. When Zee the Zombie encounters prejudice while trying out for the football team, this is no *Remember the Titans*; in fact, his teammates on the offensive line manage to pull exactly the same tricks previously seen on the classic Goldie Hawn comedy *Wildcats*. Wildcats was also the

name of the basketball team in the aforementioned *High School Musical*, of course; in this way, the film is a circulation of clichés, an achievement of simulacra Baudrillard would struggle to imagine. And it's wonderful, to the extent that its disregard for authenticity perfects the affective strengths of romantic musicals. It also has no hesitation in highlighting the shifting registers and re-arrangements of recognisable tropes that allows it to be, in one moment, a comment on racial segregation, and the next moment about overcoming low self-esteem; just as *Army of the Dead* is in one moment an exploration of primitive societal violence and in the next moment a bizarre update of *Jason and the Argonauts*. Perhaps the epitome of this is halfway through this latter film, when a magnificent white zombie tiger appears with no obvious role in the story other than to reappear sometime later.

Does this zombie intelligence simply represent a pale imitation of originality, a vain effort to re-energise a saturated market? Perhaps. But it is also the case that the territorialising of zombified intelligence in these films is not limited to the organismic representation of a violent body politic – the stupid as an enemy – but an assemblage of certain rhetorical conditions, themes and tropes which helps establish the very *possibility* of this enemy. The threat of intelligent zombies – as with the dangerously stupid – is engaged via the mediation of assembled repetition; not only the repetition of social and narrative forms, but precisely those forms for which repetition is key.

Ruth Amossy once argued that clichés are a common property which we may not want to own, yet nevertheless do. Jakob Norberg has reinterpreted this in the light of late capitalism's dependence on intelligence as a form of currency, made valuable by the legal claims of copyright, the economies of knowledge production, and the ethos of innovation. None of these bulwarks of 'intellect' protect against the overuse, and subsequent spoiling, of ideas, images and language as

clichés. In this way, 'the cliché is a symptom that cannot be fully eliminated (in capitalism), despite constant attacks on their badness, because clichés are generated when a market logic demands the enforcement of ownership over forever un-ownable words' (2018, p.79). For Norberg, the radical nature of the cliché lies in its ability to 'remind'; it is this reminding, as a mode of familiarity, that provides a form of ownership which subverts the very propriety of what it is to 'own'.

We are, by now, well used to the celebratory statements over cunning attacks on capitalist models of ownership, and the heroic disrupting of markets, and, in Joshua Gamson's words, 'let "newness" overshadow historical continuity' (2003, p.259, cited in Dean 2005, p.62). Norberg's point about clichés takes the opposite route: his strategy, like the initial appearances of the intelligent zombie, presents problems for resolving any distance between the intelligent and the non-intelligent, especially with a nostalgic use of memory, because it presents this distance as time-consuming without actually progressing anywhere. Indeed, it can't go without saying (at least if the reviews are anything to go by) that all of these films are *far* too long. Each one comes in at well over 2 hours long despite relatively high-concept plots. Furthermore, this is not simply down to lacklustre editing; it is amplified throughout by the presence of repetition which reinforces the extensive length. Towards the end of *Zombies*, the songs are repeated from earlier. In a scene in *Army of the Dead*, a character simply declares 'oh, fuck!' every few minutes as his impending fate grows more gruesome. The different elements of the plot – that he is carried off as a sacrifice to ensure the safe passage of the rest of the team; his discovery that there are a large number of Alpha zombies of which the team are not aware; his realisation that he is going to be eaten; the revelation that there is an Alpha leader, and so on – are all accompanied by the repetition of the same single profanity, making it difficult to really differentiate

between the bad and the *really* bad. Time simply passes, without a sense of progression or development. It is not a case of making something – truth, narrative, meaning – matter 'again'; it is simply the representation of again and again.

In our examples of intelligent zombies, the attempts to reconcile this particular form of dangerous stupidity becomes tangled between the portrayal of primitivism and the nostalgic re-assertion of mythical heroes in the Harryhausen-esque finale to *Army of the Dead*; between the exposing of the conspiracies directing the masses and the inevitable sacrifice of the hero in *Redcon-1*; and between the faith in dialogical reason and the postmodern play of references that flatten the distinction between stupid and intelligent. We could be happy with any of those three, of course. But underlying them all is the nagging question of the cliché: not simply as a worn-out phrase or hackneyed plotline, but as a form of curated repetition or distorted memory. Such is the real threat of the zombie. Such is the real danger of stupidity: not simply its opposition to truth, but its locus of the remnants and entrails of any truth subjected to enough repetition.

Afterword

Perhaps it is not surprising that, just as Gustave Le Bon found in *The Crowd*, the problem of the stupid lends itself to being an epidemiological issue rather than an epistemological one. Stupidity as a disease creates a natural and instinctive barrier between the bearers of knowledge and the sufferers of ignorance; a barrier which is increasingly more difficult to sustain in terms of the knowledge practices themselves. The commonplace that stupidity is a (both real and metaphorical) plague is not a summary representation of ignorance, but rather an establishment of the conditions of engagement, ensuring an interpretative complicity between each side in the war for intelligence. Just as we noted in Chapter Two, such

an immunological relationship is inherently unstable: not just because viruses develop and mutate of their own accord in and around the barriers set up against them, but also because the metaphor of immunology is by now largely a function of nostalgia rather than an adequate description of the knowledge society.

Take a book such as Eric Bailey's *The Cure for Stupidity*, which begins with an exercise in reading comprehension to make sure that the reader is 'qualified to read this book'. For this piece of intellectual gatekeeping, the reader is asked to count how many 'f's' there are in the 'italicized paragraph' below. The exercise is a trick to show how human communication falls into certain traps: the 'italicized paragraph' has a number of words beginning with f, and if you count them there are thirteen. But Bailey reveals that 'There are seventeen fs in the italicized paragraph.' The other four come from the end of the word 'of', which most readers omit.

The counting of the "f's" is actually a wonderful demonstration of the first Principle of Human Understanding – what I call the 'Illusion of Certainty,' which comes from a common psychological principle...As adults, our brains like to project certainty, even when we are uncertain...[W]hen we have an answer (show that we know something), we frequently become more confident (more certain) that we are right. (2019, pp.3-4)

The problem with all of this is that the 'italicized paragraph' is not, in fact, italicized. And while this is only a minor typographical inconvenience, I raise it not to sneer but to note that this is also surely a better demonstration of the illusion of certainty: rooted in faith in the innocence of the medial carrier, the disregard of the repetitive processes that form any communication that are far from error-proof. It is also somehow telling of the grandeur

attributed to Bailey's 'cure', from his initial test to allow the reader into his secrets, to the claim to offering 'First Principles of Human Understanding', deliberately calling to mind some of the great philosophical tomes that have shaped Western thinking – Descartes, Locke, Hume – without utilising them, and instead regurgitating 'behavioural science' at its very shallowest.

Coincidentally, Bailey may be aware that the first principle of David Hume's *Enquiry into Human Understanding* is a distinction between species of philosophy: the first 'considers man chiefly as born for action', while the other sees human nature 'as a subject of speculation'. The first species, Hume suggests, 'treat their subject in an easy and obvious manner...they make us *feel* the difference between vice and virtue'; the second aims to 'form his understanding more than cultivate his manners'. (1756/1999, p.87) It is fair to say that the rhetorical deployment of the dangerously stupid fulfils the first species of Hume's philosophy. Yet, in doing so, it challenges us to look in more detail at how one speculates on understanding amid the mobile assemblages of commonplaces that form public discourse today.

Chapter 4

The Politics of Irony, Reconsidered

It is not difficult to see how truth and nostalgia become interlinked. In both *Heroes: Mass Murder and Suicide* and *The Uprising: On Poetry and Finance*, Franco 'Bifo' Berardi paints a picture of a 'kingdom of nihilism' (2015, p.2) where the classical tradition of heroism disappears with the speed and complexity of late modernity, replaced by 'gigantic machines of simulation' (p.5), producing identities and sub-cultures in the void left by the loss of epic discourse. Here, amid this sea of culture wars, Twitter cancelling and resignation at the stupidity of others, Berardi claims, 'lies the origin of the late-modern form of tragedy: at the threshold where illusion is mistaken for reality, and identities are perceived as authentic forms of belonging' (2015, p.5).

How is stupidity addressed in this context, where truth is first and foremost *remembered* rather than created? If this late-capitalist scene provides a fertile ground for stupidity, it leaves the options of resistance to ignorance limited. On the one hand, there are the calls to see through the mechanisms of late-modern tragedy: resist the internet, refuse social media, find a place outside of communicative simulation. On the other, there is the insistence on the need for a heroically renewed 'truth' or critical method that can clarify ambiguities and designate those in the right from those in the wrong, and thus re-assert the authority of intelligence. Berardi suggests that such approaches will only result in frustration, critical malaise and depressive attitudes, given that they oversimplify the mechanisms of late capitalism, and continue to insist on territorial distinctions between the stupid and non-stupid that are difficult to sustain other than through 'simulation' or 'identities'. Instead, he argues, if this

dystopia is inevitable, then it can only be resisted with irony.

At first, this answer is surprising. After all, doesn't a turn to irony only *accentuate* stupidity, encouraging the predictable sniggers, irritating in-jokes and faux-naïf marvels we have already suffered enough? Yet, for Berardi, the prospect of irony is not only a form of critique, but also a medium of hope; indeed, it is *only* irony that can resist the contemporary frustration of public discourse.

He remains elliptical, however, on the matter of how this is put into action, both practically and conceptually. In this sense, while Berardi's extensive work on the neoliberal technologies of society marks out a very different route to his conclusions, his concept of irony itself is aligned with a number of thinkers from the broad liberal tradition of philosophy who have wrestled with the problem of irony as a form of political critique. For example, Cynthia Willett (2008) has aligned irony with a pluralistic conception of liberal freedom; William Curtis (2015) has developed Richard Rorty's (1989) notion of contingency in order to argue that irony creates civic virtues; Jonathan Lear has framed irony as an uncanny disruption to our everyday roles and identities which provides us with the capacity to live a 'distinctively human life' (2011, p.9); and Richard Bernstein (2016) has turned to irony as a way of disrupting the theoretical orientation of contemporary philosophy and returning it to a concern with practical, lived existence.

While differing in approach and conclusions, all of these share two assumptions: first, that the present social, cultural and political climate demands a critical response; second, that irony serves to subvert, puncture and challenge rigid practices, whether such practices are embedded within stale or overly-formal traditions of thought, or within newer trends within the context of critical thought – 'post-liberalism', 'post-truth', 'populism', and so on – which may stifle critical debate and robust political discourse. For all of these thinkers, irony offers

a way of subverting the seeming inevitability of the present age. If these two assumptions frame the recourse to irony as a form of critique, the practice of a *politics* of irony is troubled by three interlinked problems in particular; problems which remain for Berardi's claims as much as his liberal counterparts. By exploring these problems, which have become impasses between those searching for ironic resistance and those fiercely set against them, I want to frame them in terms of the battleground of stupidity. In doing so, a more detailed picture begins to emerge about both what is at stake in the relationship between irony and the stupid, and what adjustments might be made to open the way towards resistance.

To begin, though, it is worth recapping Berardi's position. According to him, late capitalism is not simply an economic position, but also a moral and ontological one, which leads individuals to exhaustion, depression and anxiety. Drawing on the analyses of post-industrial capitalism informed by Deleuze, Guattari, Baudrillard, Negri and Marazzi, Berardi's writing focuses on the ways in which the development of capitalism and neoliberalism have entered the human psyche, emotions and desires as well as working practices. He concludes that this current dystopia 'has to be faced and dissolved by irony' (2015, p.224). For Berardi, this need for irony is threefold. First, he notes a 'desperate lack of irony' in modern identity; a consequence of our traditional models of heroic agency being replaced with 'gigantic machines of simulation' (2015, p.5), and the resulting uncertainty producing aggressive desires for identities and sub-cultures. Second, this is enforced by what Berardi terms the prevalence of 'positive feedback' in the social field. In cybernetics, he notes, negative feedback is when the output of a system opposes changes to its input, thus reducing the significance of the change. But positive feedback increases these agitations in response to the agitations themselves. This model serves Berardi as a model for his thinking on our

social interactions: 'in conditions of info-acceleration and hypercomplexity, as the conscious and rational will becomes unable to check and to adjust trends, the trends themselves become self-reinforcing up to the point of final collapse' (2012, p.12). Positive feedback here reflects in many ways what Eli Pariser (2012) termed *filter bubbles*: the combination of personalised algorithms presenting information a digital media user is likely to agree with, and the academically discredited but still-widely-used social psychological principle of groupthink, produces a limited reality tailored to views and beliefs we are already comfortable with. Yet for Berardi this is not simply an issue for digital media, but for politics and its 'techno-financial authoritarianism' which blends it with economics. Rather than offer a site of challenge or improvement to existing systems, as a system of negative feedback might, he argues that contemporary politics works to ingrain itself as the *only* system, by regulating education, limiting public inquiries, and so on (Berardi, 2012, p.13). Third, Berardi acknowledges that within such self-reinforcing systems, the question is not 'what can be done?', but 'what can be done, when we know nothing can be done?' When 'everybody knows' what the wrongs of neoliberal theology and capitalist absolutism are, he argues, 'denunciation is feeding frustration and leading nowhere' (2015, p.200).

A different modality is therefore required to introduce negative feedback and challenge the circularity of the current social field. The modality Berardi recommends is a renewed 'ironic autonomy' (2015, p.225). More than simply a rhetorical trope, Berardi appeals to both an ontological and ethical emphasis on 'the independence of mind from knowledge' and 'the excessive nature of the imagination' (2015, p.226). Together, these build 'sympathy among those who, engaged in the ironic act, arrive at a common autonomy from the dictatorship of the signified' (Berardi 2012, p.167). This constitutes the antidote to positive feedback: ironic autonomy constitutes 'the ability to

escape environments where the positive feedback is switched on' (2012, p.13).

In many ways this effectively summarises the malaise of 'the stupid'. The commonplace of the stupid is rampant in all three of the areas he cites in support of the need for more irony in the world: the intrusion of the marketplace into academia, contributing to a focus on income generation over radical ideas; the consumer culture being established within education with governmental interventions ensuring 'useful' subjects are taught at the expense of the creative; positive feedback reduces (according to Pariser, at least) the amount of alternative or dissenting voices that are heard by different groups; and, finally, the frustration with and anger at 'the stupid' as a group, whatever the particular debate they appear within, as an unchangeable crowd suffocating hope from the political imagination.

Precisely because of these very similarities, Berardi's call for 'facing and dissolving' neoliberalism with irony is problematic. This is not just because it flies in the face of the conventional responses to the sea of misinformation and polarity in public debate. Shouldn't we be focusing more on understanding everyone's viewpoint? Or re-asserting the primacy of facts over interpretation? In that sense, isn't irony also rather…stupid? After all, the history of irony bears an uncomfortable relationship with political interventions. Some time ago I noted that, 'the various incarnations of the "age of irony" (an age which has been invoked in a number of different contexts in the past 300 years or so) are repeatedly identified by a refusal or inability to form recognisably accountable "positions", particularly in response to "serious" events' (Grimwood, 2008, p.350). It is no coincidence that ages of irony are typically identified *post hoc* by the announcements of their death, rather than the prospect of their arrival. This is in part due to the inherent problem of defining something designed to problematise our immediate

interpretations of the world. However hopeful this recourse to irony may be, situated as it is within a history of Romantic idealism, Weimar hedonism and postmodern subversion it clearly needs to negotiate the core problems facing any prospective contemporary politics to resist the commonplace of the stupid. As such, it's time to look at the three problems for irony in more detail.

First problem: fake irony

The first and, perhaps, most obvious problem is the fact that irony itself is persistently theorised as a fraudulent form of political critique. For many, it is *precisely* the prevalence of irony which allow malaise to fester and grow. One example of this view was presented in Christy Wampole's *New York Times* article following Trump's election, 'How to Live Without Irony (For Real This Time)'. Here, Wampole recalled her earlier criticisms of the cultural dominance of 'apolitical irony', 'a vacuity and vapidity of the individual and collective psyche' which served as a defence mechanism against blunter realities. 'For the relatively well educated and financially secure,' she argued, 'irony functions as a kind of credit card you never have to pay back.' But with the election of Trump, the self-serving recourse to irony had been undermined:

> That Age of Irony ended abruptly on Nov. 9, 2016, when people in many of the irony-heavy communities...blue bubbles of educated, left-leaning, white middle-class people in cities, suburbia and college towns, of which I am a part — woke up to the sobering news of Donald J. Trump's victory, and perhaps a new reason to ditch the culture of sarcasm and self-infantilization.
> (Wampole, 2016)

While certainly not an in-depth philosophical treatise,

Wampole's article nevertheless represents well a current of philosophical thought that seeks to expose irony's pretensions to critique: a current as old as irony itself, which remains prescient to any attempt to privilege irony as a form of critique. Something is *wrong*, and this wrong requires, if not quite a 'final vocabulary', a response that is stronger than the celebration of endless contingency that the ironists seem able to offer. For Wampole, irony is a defence mechanism because it reduces the bearer to the level of the stupid, something akin to Nietzsche's happiest animal who is happy only because it never remembers anything. And while the 'educated' and 'left leaning' were satisfied with base amusement, this simply allowed a darker stupid to take hold.

Hence, this culture of self-imposed infantilisation all looked rather silly when the Trump administration took office. Indeed, while Richard Wolffe (2020) might have noted that 'the irony gods have truly bequeathed us a feast of overconfident idiots' in the White House, they were nevertheless in the White House. Writing after the administration's demise, Grabar and Mathis Lilley summarised: 'When the story of this era is told many years from now, students and history enthusiasts will learn about Trump's lies, corruption, self-enrichment, and abuse. What they may not grasp – and what even now is hard to comprehend – *is just how stupid it was* to live through' (2020, my emphasis). In this way, the spirit of Wampole's criticism captures the urgency provoked by both the contemporary political situation, and the need to resist the seduction of irony as a kind of self-deceivingly stupid response to it. In the wake of what she saw as the political failure of this age of irony, Wampole argued that a *'new sincerity'* is needed. When irony has undermined the sincerity of politics, only the re-establishment of that sincerity can save us.

For his part, Berardi agrees that irony may well be mistaken for what he terms cynicism – hallmarks of which may well be 'sarcasm and self-infantilization'. While both irony and

cynicism imply a 'dissociation of language and behaviour from consciousness' (2012, p.165), cynicism is a 'deceived moralism'. Drawing on Peter Sloterdijk's momentous *Critique of Cynical Reason*, Berardi sees contemporary cynicism within the 'conformist majority, fully aware that the law of the powerful is bad, but bending to it because there's nothing else to do' (2012, p.162). Cynicism internalises the 'impotence of truth'; left with the ashes of failed utopias, the cynic is the critic who has lost their faith that truth can ever be fulfilled. But 'the ironist,' Berardi states, 'never had faith to begin with' (2012, p.166), and therefore offers a more radical vision of critique: it implies an infinite process of interpretation.

Simply defining irony as one thing and cynicism as another is not, however, particularly convincing in this case. As Paul de Man commented, after providing a long list of philosophers each of whom criticises the last for failing to successfully identify what irony is: 'definitional language seems to be in trouble where irony is concerned...It is very difficult, impossible indeed, to get to a conceptualization by means of definition' (1996, p.165). Indeed, I have argued elsewhere that irony is first and foremost an interpretative *practice*, and this means that it must be identified in terms of themes and currents of its use, rather than abstract, fixed definitions. Because irony always infers moving beyond the immediate word or sentence, any definition of irony must necessarily itself be potentially ironic (Grimwood 2012, p.70). In this sense, while the content responds to different events, it can be said that the *ethos* of Wampole's criticism sits firmly within a well-established theme within the politics of irony. It is a theme echoed in Roger Rosenblatt's infamous claim that if there was one good thing to come out of 9/11, it was the end of irony: a violent reminder of the seriousness of what was 'real' could draw to a halt the perceived relativism of postmodernity. And if irony *were* to be taken seriously, then it was left open to the charge that ironic interpretation, like

Bergsonian comedy, could only ever uphold the status quo: a sentiment famously summed up by the 1980s slogan of the Los Angeles-based artists' collective Inventory: 'Ironic mimesis is not critique, it is the mentality of a slave!'

Philosophically, the first problem for a politics of irony brings us to an impasse where discussions focus on how to discern 'good irony' from 'bad irony', and defending what counts as good (disruption, humour, contingency) from what is charged as bad (cynicism, scepticism, relativism and blind or self-deceptive stupidity). This impasse is difficult to overcome, because the two sides don't necessarily oppose each other in a conventional manner. After all, humour can be cynical, scepticism can be disruptive, and so on. Instead, critics of ironic approaches take the strategy of exposing irony as something else: when cast as political critique, it becomes something *other than* irony in the traditional sense (scepticism, relativism, naivety, etc. – see, for example, Haack, 1995; Bacon, 2005). In response, the ironists may counter that this reduction is too blunt, and that the fundamental appeal of irony (as opposed to cynicism, pure and simple) is lost, because its critics are attempting to explain irony in terms of the very ways of speaking and writing it is attempting to disrupt. The impasse remains.

Second problem: the politics of sincerity

The second problem for a politics of irony can be seen when one considers what both sides of this impasse *share*. Whether advocating irony, or furiously rejecting it, both sides of the debate typically assume that the issue is how we choose to enter into an otherwise un-ironic space of politics and political critique. For Berardi, ironic autonomy constitutes a form of resistance precisely because it presents what is absent from, and seemingly impossible within, contemporary culture. But the fields of practice within which political critique takes place are far from un-ironic. As Don Waisanen notes, 'in a trend that

shows few signs of waning, we increasingly see those in power using comedy to serve their own political ends...Comedy by the powerful has shifted from an informal tool to a formal expectation. Even the US Central Intelligence Agency now engages in satirical tweets' (2018, p.160).

This is, I hasten to add, a specific utilisation of irony as a form of communication. It is not, in this sense, the same as when, to his critics' delight, Donald Trump seemed to suggest injecting bleach into one's arm as a way of combatting COVID-19, and later dismissed this as sarcasm. While this incident may provide ammunition to those who see irony as an excuse or mask for plain stupidity, that simply takes us back to the first problem. The issue is not isolated incidents of claims to or against irony, but rather a more constant presence of irony within politics itself.

In his essay *The Production of Sincerity*, Boris Groys discusses the question of whether art can engage in politics, or simply provide an aesthetic façade for political decisions. For Groys, this question in fact misses the point: the problem is, 'not art's incapacity to become truly political. The problem is that today's political sphere has *already become* aestheticized' (2010, p.40, my emphasis). The result, Groys suggests, is 'when art becomes political, it is forced to make the unpleasant discovery that politics has already become art – that politics has already situated itself in the aesthetic field' (2010, p.39).

The machine of media coverage does not need any individual artistic intervention or artistic decision in order to be put into motion. Indeed, contemporary mass media has emerged as by far the largest and most powerful machine for producing images – vastly more extensive and effective than the contemporary art system.
(Groys, 2010, p.40)

I do not read Groys as saying here that politics has 'become' art in the totalising sense that it now hangs in a gallery – that politics is art, and *only* art. Rather, identifying the aesthetic properties of politics wrong-foots the practical points of reference for artistic resistance: sincerity, authenticity, decision, affective reality, and so on. In the same way, could it not be suggested that politics has out-ironised the ironists? Far from an ambivalent tool of critique from the edges, irony now seems to perpetuate the circulation of political discourse. If so, this fact would not only displace the critical power of irony which Berardi promises (how can irony 'disrupt' that which is already, in some sense, ironic?); it would *also* challenge Wampole's appeal to 'sincerity' as a mode for re-engaging politics, for it is not clear how sincerity could emerge so cleanly from a context that is saturated in irony.

There is a further aspect to the ironic space of politics. In *The Compass of Irony* (1969), D.C. Muecke introduced a now-common distinction between verbal and situational irony: one is intended by a speaker, the other observed from a situation. As Muecke notes, intentional, verbal irony dominates intellectual discussions – whether literary, aesthetic, philosophical or political – because it is more straightforward to account for and document. Situational irony, meanwhile, is far harder to theorise because it is transitional, fleeting and dependent upon variations of audience response. Yet, while it is true that, as discussed above, the use of irony as a tool of politics seems to have increased, the contemporary political discourse can also appear as an ironic space because of its situational characteristics. In many ways, this is best captured by the now-common refrain from across the political spectrum that the effect satire has (which depends almost entirely on irony) becomes impossible due to each party's policies and actions effectively satirising themselves (see, for example, Stanley, 2015; Groskop, 2016; Goodfellow, 2018). This constitutes something different to

the deliberate use of irony by political groups and politicians, and as such something beyond the reach of verbal irony alone. We can take some examples straight from the shelf: the British Conservative Party widely denounced the opposition Labour Party's economic policies in the 2015 General Election campaign, before adopting them once in office; the biggest recruiter of terrorists in the United States is reputedly the FBI; rather than bringing down the financial system, the 2008 banking crisis in fact served to confirm and consolidate neoliberal ideology; after leaving the European Union under the auspices of a campaign promising the ending of free movement, the United Kingdom flew in Romanian fruit pickers to relieve the economy during the COVID-19 crisis. In fact, the ironies of COVID-19's political theatre would require a book all to themselves.

It may be objected, of course, that the examples above do not really constitute irony; or, if they do, only in a minor way compared to better typologies – tragedy, hypocrisy, contradiction and so on. Conversely, Žižek (2004) notes that the 'reversals, crises, [and] reinventions' of late capitalism render normal life 'carnivalized', 'so that it is the critique of capitalism, from a "stable" ethical position, which, today, more and more appears as an exception'. Why, then, call this ironic? What is significant about these examples, for me, is that their irony arises from specific juxtapositions and unintended *curation* of information. There is nothing ironic about the Conservative Party adopting a particular economic strategy, *until* it is placed next to an account of them discrediting the same policy only a few years before. In this sense, the media landscape upon which political discourse takes place establishes conditions for perpetual irony; but an irony which clearly goes beyond Muecke's verbal model. As such, the importance of identifying examples of ironic politics as bearing the functional characteristics of irony – rather than, say, tragedy, or hypocrisy – becomes significant only in relation to proposing or rejecting a politics of irony: that is, when facing

the impasse between Berardi's ironic hope and Wampole's non-ironic sincerity. It is in this sense that they suggest a context in which irony has become a *condition* of politics.

One reason for this condition is, of course, provided by Berardi's account of positive feedback in post-industrial capitalism: the rise of simplistic truths and moral judgements aligning with the increased complexity of the globalised world. It is no surprise if attempts to produce a clear and concise sense of moral agency in response to such contingency end up producing situations which project irony, accidentally or otherwise. This condition presents itself through the affirmation of non-contingent truths in response to contingent contexts: or, to put it another way, contingency being a formative foundation for the strength of the non-contingent claim. This is perhaps another way of describing what has been termed 'post-truth'. Underlying this is a far more banal reason: the sheer array of digital and social media carrying, storing and presenting information and narrative. Under such a condition, we are always faced with a range of possible links, juxtapositions and resonances which all offer the possibility of an ironic situation emerging, and sincerity being placed in question. In this sense, we are not dealing with mere contingencies or accidents, but a form of medial curation.

It is for precisely this reason, I think, that the accusations of lying levelled at both Johnson and Trump fail to land serious blows. True, it could be the stupidity of the public in either not realising a political leader's actions have contradicted an earlier promise; or that a blind devotion to banal ideology – whether Brexit, anti-Leftism or MAGA – renders intelligent and nuanced critique irrelevant. I suspect it is more to do with the terrain on which such actions and promises are circulated, where sincerity is a modality that is increasingly hard to sustain. Writing in *The Guardian*, Andy Beckett notes how Boris Johnson's government, 'is both lazy and hyperactive, ambitious and complacent,

dominant and volatile. It zigzags between different policies and ideological positions, confusing commentators, opposition parties and Conservative supporters – and sometimes even its own ministers.' Of course, it is entirely possible, and often quite right, to fixate on the qualities of individuals in the government itself to explain such contradictory rulings. But this doesn't annul the conditions through which such contradictions become visible.

Third problem: the slippage

Where does this leave a potential politics of irony? Perhaps the most conventional response is that a world of ironic possibilities will remain nothing but latent possibility, until it is *used* in some way. This then returns us to the prospect of discerning 'good' uses of irony from 'bad', and thereby using irony to puncture the tyranny of universalism without leading us into an abyss of nihilistic in-jokes. This solution is, of course, familiar from archetypal texts such as Wayne Booth's *The Rhetoric of Irony*, whereby he explicitly focuses on 'stable' or 'controlled' irony; or from the appeal to the 'liberal' irony found in Richard Rorty's *Contingency, Irony and Solidarity*, which suggests that using irony as a form of civic virtue is a way of tempering our truth-claims. The acknowledgement of contingency (placed within certain limits) can then form the basis of a better politics: it 'helps make the world's inhabitants more pragmatic, more tolerant, more liberal, more receptive to the appeal of instrumental rationality' (1991, p.193). Rorty's critique of universal truth-claims depends on groups recognising the integral limits of what truth they can claim. In this sense, everything is context-dependent: 'It seems to me that I am just as provincial and contextualist as the Nazi teachers...the only difference is that I serve a better cause, I come from a better province' (Rorty 2000, p.22). This depends, in turn, on a provincial ability to claim that 'we are ironists'. There is, it seems, no irony without boundaries. As such, the

politics of irony would involve *gatekeeping* our pretensions to holding a universal truth, and thus become merely a function of the wider liberal philosophy to keep our truth-claims humble and our political views honest.

Yet such gatekeeping is neither the self-protection of which ironists are accused (removing themselves from a critical, or challengeable position, because everything is ironic), nor the political criticism that Berardi argues offers us hope. Rather, it is a re-modelling of Roland Barthes' essay 'Operation: Margarine': 'To instil into the Established Order the complacent portrayal of its drawbacks has nowadays become a paradoxical but incontrovertible means of exalting it' (1973, p.41). Through a range of examples, from films and novels about the Army to *Astra* margarine adverts, Barthes shows how established values are exposed for their 'pettiness' and 'injustices' (the army is stupidly tyrannical; margarine is cheap), but are then saved not only *'in spite of'*, but 'rather *by* the heavy curse of its blemishes' (p.41). The discipline of the army allows the hero of the story to overcome the wrongdoers; margarine is, in fact, just like butter but cheaper. Irony threatens our capacity to control our meaning, but is rescued by re-asserting a controlled, meaningful irony.

The problem here is that we seem to have simply slipped from the second problem (that politics is itself ironic) back to the first (the impasse between 'good' and 'bad' irony). In fact, this slippage is itself a consequence of the ironic conditions of politics. The case of 'post-truth' serves as a useful analogy here. On the one hand, the nomenclature of post-truth is often used to describe the highly publicised criticisms of scholarly expertise within political arguments: from Gove's claim that 'Britain has had enough of experts' to Donald Trump's comments that 'nobody really knows' if climate change is real (Eilperin, 2016), and all in between. The Oxford Dictionary defines the term as 'relating to or denoting circumstances in which objective facts

are less influential in shaping public opinion than appeals to emotion and personal belief'. The somewhat natural response to this on behalf of the 'experts' is to re-assert the foundations of a rational politics of truth and progress. In this response, as I've previously suggested, all-too quickly terms such as 'post-truth' and 'fake news' that are embedded within the complex and interactive circulation of new media become ciphers for the nostalgia of certainty. The result is an inevitable impasse: on the one hand, a post-truth politics that understands the fallibility of truth, while at the same time insisting upon ever-more strident truth-claims; on the other hand, those dismissing that truth might be fallible by appealing to a crude nostalgia for, if not 'facts' themselves, then the social and academic structures that produce facts. The very term 'post-truth' – attributing a definitive name to something that is necessarily multifarious – is itself a performance of post-truth, in this sense.

What has gone wrong, then? In thinkers such as Rorty we see an implicit model of agency which remains built around *verbal irony*; or, at least, the requirements of practical critique which shape verbal irony as the dominant mode of studying irony. Not only does this model suggest that irony is a tool of agency, but it also presupposes certain dialogical spaces which remain largely *abstract*: a speaker and an audience, a listener who understands a context, a shared understanding.

These are fantastic tools for challenging, say, the hegemony of rationalist justification or pretensions to universal truths; or, as Richard Bernstein has argued recently, for redressing the imbalance between philosophy as a 'theoretical' discipline, and its original concern with living a good life. But it has always been the case that verbal irony is a product of the conditions of theory (that is, the practice of critique within particular institutional and cultural limits: the requirements of a 'well-evidence argument', the interpretative closure of a conclusion or standpoint), rather than a reflection of ironic reality. That

is to say: verbal irony provides a clearer sense of what irony 'means' by locating it within a speaking agent. The risk and uncertainty of irony is then reduced to a question of should we use it or shouldn't we. This, though, has already resulted in the first problem for a politics of irony: the impasse. Furthermore, this impasse was premised on irony as a *tool* of agency – whether a tool for critique, or a tool for hiding behind the pretensions of critique – which the second problem for a politics of irony suggested was not always applicable to the specific context of how political discourse circulates. Indeed, the situation of ironic politics calls more for Paul de Man's observation that:

> The way to stop irony is by understanding, by the understanding of irony, by the understanding of the ironic process. Understanding would allow us to control irony. But what if irony is always of understanding, if irony is always the irony of understanding, if what is at stake in irony is always the question of whether it is possible to understand or not to understand?
> (de Man, 1996, p.166)

At this point we might note that there is a complementary relationship with stupidity. The focus, in many public debates, is on stupidity as *cognitive* stupidity: while verbal irony depends on an agent deploying it, stupidity depends on an agent refusing to deploy their critical faculties. Both of these make sense when framed in this abstract way. However, as de Man's quote suggests, there is reason to be suspicious of the comfort with which we rest on this abstraction. Two examples serve to show this with the case of irony; and from this, its relationship to stupidity can be better seen.

Two examples
I am suggesting that when irony becomes synonymous with

contingency, we lose what we might term the *curatorial* aspect of irony's emergence and circulation: a curatorial aspect that is fundamental to the notion of politics out-ironising the ironists. In the current media field, the spaces for interpreting irony are far more multifaceted and complex than the model of verbal irony allows for, and as such require particular positioning and representing of irony's relation to the material, social and political encounters. Without such an aspect, the conditions of irony are substituted completely for a blunt form of cynical stupidity. I want to illustrate this notion that the slippage from the second problem to the first is based on the spaces of interaction between irony and interpreter with two, necessarily arbitrary, examples of a politics of irony; in the interests of balance, the first is negative, the second positive, but both enact the problem of slippage discussed above.

First example. In *Kill All Normies: Online Culture Wars from 4chan and Tumblr to Trump and the Alt-Right*, Angela Nagle provides an excellent account of the online culture wars that have emerged from the margins of the internet to exert significant influence on political views and decision-making in the United States. At one point, she notes the alt-right distinguishes itself from older right-wing sensibilities by assuming 'the aesthetics of counterculture' (2017, p.28), and harnessing the mythos of the 'moral transgressor as a heroic individual' (p.31), previously the domain of the left. In this way, internet trolling, abusive or misogynistic comments and violent threats adopt a Bakhtinian carnival-esque modality. In 'the style of the rightist chan culture,' Nagle warns, 'interpretation and judgement are evaded through tricks and layers of metatextual self-awareness and irony' (Nagle 2017, p.31).

Nagle's excellent research is illuminating and raises a number of troubling aspects of the alt-right internet presence. The one problem of her analysis is that it frequently involves, in each case study, focusing on the original meaning and

its initial small-scale circulation of particular memes, *then* suggesting that this originary meaning subsequently governs their proliferation in mainstream political commentary and dialogue. Thus presented, a localised irony between handfuls of members of an internet forum becomes something far more dangerous, with a presupposed non-critical, passive response. Enlarged as such, the threat of stupidity is clear: both with the conspiratorial content-producers and the hapless consumers of such content. Nagle thus adopts an inherently conservative view of irony throughout her book: she positions it purely as an intentional, controlled trope which then functions as a cynical excuse for posting offensive words and images. What is missed here is precisely the use of memes *beyond* their original creation: their circulation, amid the more general circulation and flows of the digital age, which, after all, constitute them as 'memes' in the first place. Missing out this element helps to position the activities of, say, 4chan memes as far more effective as they may well be, because Nagle looks at their actions through every lens *except* irony. In short, there is an everydayness which Nagle refuses to acknowledge: that one can see a meme which perhaps prompts a wry smile, perhaps a raised eyebrow; perhaps a 'like', perhaps a 'share' or perhaps a sigh before the thumb moves on to the next one. For example, when the research group Revealing Reality recorded participants' smartphone usage during the 2019 UK General Election, they found:

> Charlie in Sunderland consumed much of his election news through memes on lad humour Facebook pages, spending more time looking at posts of Boris Johnson using the word "boobies" than reading traditional news stories. Fiona in Bolton checked out claims about Jeremy Corbyn's wealth by going to a website called Jihadi Watch before sharing the far-right material in a deliberate bid to anger her leftwing friends. (Waterson, 2019)

Such an analysis suggests, just as Kerr, Kücklich and Brereton (2006) have before, that users of new media experience different and unique combinations of both 'cultural' and 'sensual' pleasure, in more manifold and heterogeneous ways than uses of traditional media. Waisanen and Becker point out that for some time communication theorists have observed that, 'like a Prezi presentation, citizens now bounce between and zoom in and out of "discursive shards" of media experience to construct an understanding of politics' (2015, p.2); 'circulation and recirculation bring more audience agency and contextual force to these matters than has been recognized' (Waisanen and Becker, 2015, p.10).

However, Revealing Reality's analysis of election news consumption focuses instead on the lack of accountability in the distribution of social media, and how this dangerously leaves all responsibility on the reader. To do this, they follow a particular reading strategy, which uses the passing interaction with social media as a form of passive consumption of what is presented as truth (rather than simply a passing interaction, perhaps ironically, perhaps disgustedly, perhaps uninterestedly). In the context of irony, they remain rooted in a verbal model of communication, rather than a situational one.

There are, of course, a number of arguments to be made about the ways in which countercultural online memes pervade everyday discourse, but these are far more complex than Revealing Reality account for. Instead, their reading strategy follows the implicit need for political critique to be *serious*. Where the content to be critiqued is not conducted in a serious manner, the task of critique is to render it serious: to expose its seriousness, to reduce it to its naked force, power, cynicism, etc. Correspondingly, the task of critique refuses to reduce its objects to sheer banality. And this becomes a problem when banal circulation is precisely the rhetorical power of such objects, and precisely its use within individual's agency. In other words,

in rendering banality serious, critique implies its passivity, its dumb-ness, its stupidity. But this is to both over-estimate the meaning of the banal and under-estimate its significance.

Second example. Richard Bernstein's *Ironic Life* attempts to develop Rorty's account of irony as a form of liberal politics by situating it as a form of 'rational justification' rather than a knowledge claim (2016, p.52). Noting that the study of irony has long been considered to not belong to 'serious' philosophical study (p.6), Bernstein considers ways that a fuller understanding of irony can return philosophy's attention to the 'art of living' (p.106). Turning this on to the training and schooling of philosophy students, he raises concerns about the way that Anglo-American philosophy has become 'almost exclusively...a theoretical discipline', linked to the 'growing academic professionalization of philosophy' (p.124) and thus risks becoming 'barren, pedantic and irrelevant' (p.125). Bernstein argues that for the liberal ironist, 'irony is *not* a form of complete detachment from worldly affairs. On the contrary, irony is compatible with a *passionate* liberal commitment to diminishing cruelty and humiliation; indeed, it *enables* this commitment' (2016, p.118-9, emphasis original). In doing so, Bernstein offers a vision of a field of politics built upon a philosophically sound account of irony: a model to oppose the nihilism of contemporary ironic politics without losing the inherent irony of any political discussion.

However, in this case Bernstein's argument that irony is a fundamental aspect of the liberal art of living is let down by a curious lack of any account of the materiality of life itself, other than examples from his teaching of theoretical philosophy, or conversing and critiquing other professors (who, despite Bernstein's claim that they are 'mavericks', are or were well-established and long-tenured professors in the field). As such, the irony that Bernstein pursues remains fundamentally verbal, and surprisingly inarticulate on the very situations it is

supposed to affect. In doing so, it lays bare a core problem with his enterprise: this model of verbal irony is often taken literally *as* a discussion (speaker speaks; audience listens), without the sense of what other conditions are in play to ensure the success of a communication. This would include social and cultural capital, prestige, trust, respect, and so on; all of which are clearly present from Bernstein's chosen interlocutors. At the same time, the liberal agency inherent to Bernstein's argument *assumes* such a model: as Cynthia Willett notes, while liberalism 'rests on moral principles that call upon autonomy, self-determination, or rational decision to guide individuals,' this notion is embedded within 'abstract notions of individualism' which is not 'designed first and foremost to negotiate parameters of freedom through the intricate social web that reaches into our libidinal core' (2008, p. 64). Consequently, it slips from the complexities of ironic politics to a rather traditional, albeit implicit, account of 'good irony', this time informed by the underlying enablers of academic standing. Furthermore, it follows from such a reading that those who block or refuse this 'passionate liberal commitment to diminishing cruelty and humiliation' are dumb in two ways: the first, explicitly, because they are driven by the techno-rationalist procedures that Bernstein wants to resist; and second, implicitly, because they are *not* part of the sphere of the educated elite which Bernstein seems unable to recognise playing such a huge part in the production of his own argument.

Ironic autonomy, reconsidered

The third problem for a politics of irony can perhaps be summarised by the suggestion that when irony becomes synonymous with contingency, we lose what we earlier termed the *curatorial* aspect of irony's emergence and circulation. For both Nagle (who is anti-irony) and Bernstein (who is not), there is an almost-exclusive focus on the production of irony, rather than its presentation and circulation. This, as we have

noted, is a consequence of a focus on liberal agency framing ironic interventions (or resistance to ironic interventions) in the political sphere. The liberal model of politics that has shaped much of the philosophical treatments of irony can introduce an implicit emphasis on verbal irony – that irony is an agential act, in effect – which becomes deeply problematic for negotiating the contemporary political domain. Within such a domain, it should be clear that irony cannot simply hold a negative value – that is, the ability to say 'no', or the ability to distort horrible things in the world into amusing memes. Rather, the examples above suggest in blunt terms that ironic autonomy is constituted by our spaces of interpretation: 'the space where social relations are reproduced, the space where knowledge and income are distributed' (Marazzi, 1994/2011, p.102).

To this end, Berardi's notion of autonomy is important to the extent it highlights the wider systems shaping the materiality of those spaces. This does not constitute a straightforward rejection of verbal irony, however, because the materiality in question is already constituted, Berardi argues, by the use of language. Our understanding of politics is not an 'exchange of signs supplied with a univocal referent', but rather following 'the slides in the relations between signs and referents, reinventing signs as functions of new referents and creating new referents by circulating new signs'. Politics, likewise, 'does not have to respect any one law, because it invents the law when it creates new relations' (Berardi 2011, p.105). This reinvention process is the hallmark of what Berardi identifies as semio-capitalism: a shift in the sphere of production from material objects to immaterial commodities such as knowledge, for which the essential tool is the mantra that 'there's no more truth, only an exchange of signs, only a deterritorializing of meaning' (Berardi, 2012, p.85). This form of late capitalism does not separate communication from production, as its previous incarnations did; rather, it 'makes of their coincidence the very

lever of economic development' (Marazzi, 1994/2011, p.34).

Thus, when Berardi argues that ironic autonomy 'refuses the game' of semio-capitalism, and instead 'implies a shared sense of assumptions and implications between oneself and one's listeners,' (2012, p.167), this should not be read as appealing to a shared communion of equals; an in-group or 'blue bubble' which Wampole described. As Marazzi points out, the sense that political understanding requires an un-ironic space in order for some form of 'common usage' to bind a political community together nowadays appears naïve. Marazzi argues that if language is a set of conventions which enables politics, then this also 'implies an original violence, because it forces us to remain silent on lived experiences for which words do not exist and to talk about contents that don't correspond to any experience' (1994/2011, p.38).

This is where stupidity returns. I began this book by noting a difference between the commonplace of 'the stupid' and stupidity itself, suggesting that the former is a rhetorical figure that has been used to represent a threat to public debate, democracy, population health, and so on, while the latter suggested something actualised in our more localised relationships. But when it comes to offering ways to resist 'the stupid', then this border becomes subject to the mediation of the commonplace, and the available language we have to address these concerns in public discourse. A commonplace requires a communal understanding, an accepted tradition of some kind that allows such an interpretative shortcut to make sense, propped up within a network of figures and alignments. 'The stupid' is a cliché that is not so much lazy or unimaginative but rather a closed interpretative circuit. As a result, when it comes to moving beyond the rhetoric of the cliché – that is, from 'the stupid' to something more palatable, or more effective – it seems that we have to either posit an alternative vision to this communal understanding (and risk ending up with something

idealised and which it is difficult to see how we could reach), or fall back into forms of cynicism (re-asserting the values of a tradition we know has already fallen short, and collapsing the distinction between cliché and reality).

A critique of politics in terms of its linguistic affects, meanwhile:

> does not mean to step outside of the world of politics "depriving ourselves of speech." It simply means – but this "simply" is crucial – to assert that within linguistic mediation the existence of each subject is always conflicted: it is this conflict that constantly modifies any linguistic presupposition.
> (Marazzi, 1994/2011, p.39-40)

Agency is always in conflict, in this sense, and such conflict always modifies any linguistic presupposition: to the extent that, we might suggest, irony is not a product of an agent, but agency is itself a product of, or response to, the inherent ironic possibilities of even the most straightforward political discourses, such as a manifesto launch or a migration policy. Ironic autonomy would then be constituted by fleeting and momentary instances when a space of interpretation is curated in terms of those possibilities, and in doing so reveals how the constellation of interests interacts to produce ironic non-sense: or in other words, reveals the situations that allow verbal irony to emerge. As I've argued before, 'the productivity of irony emerges within this relationship between the identification of an ironic moment and the establishment of a discourse of the particular event in which the ironic moment takes place' (Grimwood, 2008, p.362).

This points to ironic autonomy emerging in somewhere like a middle-term between the emphasis on agency within liberalism, and the broader psychopolitical accounts of

neoliberalism found in Berardi and his post-workerist colleagues: what Willett describes as expanding 'our focus from the individual and her choices to embodied social creatures and new forms of belonging' (2008, p.147). It is precisely within such a middle-term, I think, that ironic autonomy becomes politically effective. The task of the ironic critic is not to re-insert ambiguity into politics, to subvert or create vertical distance between themselves and the *realpolitik*; but rather to continue to *articulate these interpretative spaces*: to identify, not the commonality of territorial understanding of shared jokes, but the dysfunctional ways in which communication travels; the ways in which such territories are constituted not by verbal agreement but situational curation. This involves looking again, not just at what informs the interpretative reduction of views and actions to the clichés of 'the stupid', but also at the ways in which sincerity is constituted: and, in particular, how political sincerity might be manifested within an already-ironic world.

Chapter 5

Speaking the Truth, Again and Again

Since Foucault's rejuvenation of the term, the Ancient Greek term *parrhesia* has come to represent the efforts of sincerity speaking truth to power. The word emerges from *parrhesiazesthai*, a word juxtaposed of *pan* (everything) and *rhema* (to express or to say). Parrhesia is to speak or express everything in an open manner, to commit to (depending on the translation) free, frank or fearless speech. In his lectures on discourse and truth-telling given at the University of California in 1983, Foucault meditated on the ways in which this relates to frankness: '"*Parrhesiazesthai*" means "to tell the truth"...The *parrhesiastes* is not only sincere and says what is his opinion, but his opinion is also the truth. He says what he knows to be true...This...characteristic of parrhesia, then, is that there is always an exact coincidence between belief and truth' (Foucault, 1983/2001, p.14).

Telling the truth was only the second characteristic of the Greek term, though. Contrasting sharply, the first characteristic consists of ambiguous proclamations, ignorant outspokenness for the sake of itself. It was a form of chatter or gossip: 'saying anything or everything one has in mind without qualification'. Foucault recounts that 'this pejorative sense occurs in Plato, for example, as a characterization of the bad democratic constitution where everyone has the right to address himself to his fellow citizens and to tell them anything — even the most stupid or dangerous things for the city' (p.13). However, 'most of the time', at least, 'parrhesia does not have this pejorative meaning in the classical texts, but rather a positive one' (p.14).

It is no surprise that, in response to the perceived separation of belief from demonstrable truth in public discourse, and the rise of what Johan Farkas calls 'the politics of falsehood', the

calls for a renewed frankness – an energised form of parrhesia – have arisen. It is equally no surprise that a truth based on sincerity of belief is fraught with risks. If telling everything is not only the root of speaking truth to power, but also the root of chatter and gossip, it is easy to see how parrhesia may slip into populism, and from populism to the threat of the masses to individual freedom. Could Trump be seen as a parrhesiastic actor, rather than a liar? How do we know if we are dealing with the speaking of radical truth to power, or simply conspiratorial gossip? 'If there is a kind of "proof" of the sincerity of the parrhesiastes, it is his *courage*,' Foucault responds. 'The fact that a speaker says something dangerous — different from what the majority believes— is a strong indication that he is a parrhesiastes' (1983/2001, p.15). For this reason, the speaker of parrhesia must be less empowered than those they speak the truth to: be that the king, the government, the manager.

In many ways, the linking of sincerity to courage, and courage to critique in the face of an oppressive power, has become the *de facto* model of the public intellectual. 'In the recent past,' Avital Ronell notes, 'the task of denouncing stupidity, as if in response to an ethical call, has fallen to the "intellectual" or to someone who manages language beyond the sphere of its private contingencies' (2002, p.37). Power may no longer be concentrated in the hands of a king, admittedly, but the rise of the stupid provides just as many opportunities for sincerity and *moral* courage to be performed against what Giroux describes as the 'neo-liberal culture of idiocy and illiteracy' (2014, p.8). Such a 'culture of idiocy', saturated by the chatter and gossip of social media, not only implies a need for courage (to speak out against the foolish), but also raises a question over what the foundation of such speaking should be.

Ronell suggests that in the past, literature has aligned intelligence with quiet reserve, whereas stupidity shouts: 'Unreserved, stupidity exposes while intelligence hides.' Yet

she goes on to point out that if it were that simple to tell the two apart, then there would be little terror or threat from the stupid. Indeed, just as John Keane (2018) points out that post-truth depends on silence and unsaid implication as much as 'bullshit' and 'buffoonery', stupidity 'is not always at odds with intelligence but can operate a purposeful exchange with its traits'. (Ronell, 2002, p.10) Similarly, placing the two aspects of parrhesia – fearlessly speaking the truth and testifying with ignorance, ambiguities, or chatter – into the spaces of public discourse in contemporary culture reveals that they are not always easy (and sometimes impossible) to differentiate, and thus prolongs the problems that post-truth raises.

The importance of parrhesia today is therefore both the way that it conceptualises the need for sincerity, and also the problems of authenticating it as such; which are not problems in an obstructive sense, but rather help to reveal what is at stake in its very effectiveness. In this sense, there is a risk in downplaying the role of chatter in speaking frankly. Commenting on Giroux's denunciation of the stupid, Elizabeth Anker and Rita Felski note that such a model of the critical thinker 'gains its intellectual leverage from an adversarial stance', which 'presume[s] a populace deluded by forces that only the critic can bring to light'. Not only is 'such a mind-set...hardly likely to influence or persuade that same populace' (2017, p.19), but it also aligns the clear-minded view of the critic with a certain moral position, supported by its own bravery.

Such an adversarial stance can be seen at work in the chapter that Paul Tabori devotes in his *Natural History of Stupidity* to the 'stupidity of doubt'. Here, he documents moments of history when the progression of human understanding was scorned by those clinging to the established knowledge of the time. Yet, he also notes that the stupidity of doubt holds an 'almost comic counterpart' in the case of the gullible (1993, p.167). The balance between the two is certainly a difficult one and, indeed, resonates

with Bruno Latour's playful noting of the uncomfortable proximity between the conspiracy theorist and the critical theorist. 'Conspiracy theories are an absurd deformation of our own arguments, but, like weapons smuggled through a fuzzy border to the wrong party, these are our weapons nonetheless' (Latour, 2004, p.230). After all, a QAnon adherent arguing that COVID-19 is a hoax, or that 'a group of Satan-worshiping elites who run a child sex ring are trying to control our politics and media' (Roose, 2021), may see themselves as uttering the truth *precisely* because it is dangerous to do so, while (they may think) the scientistic defences of government COVID-19 data only speak from the comfort of believing they are indisputable. And where, the conspiracy theorist might ask, is the courage in that? But when one encounters arguments for the distinction between scientific peer review versus 'what I read on the internet', rational clarity versus populist bluster, and objective evidence in the face of ludicrous counterclaims, these not only draw on the positive form of courageous parrhesia – truth is not spoken from a position of institutional power but as noble interventions into public discourse fighting against the dangers of ignorance – but also still need to circulate and repeat if they are to be effective. The question, then, is how do aspects of chatter, gossip and repetition mediate the ethical demand to speak courageously; and in turn what sustains the moral aspect of this demand to condemn stupidity?

Demonic gossip

In a little-known paper in the *International Journal of Ethics* in 1936, Henry Lanz answers this in exacting terms. He begins with the striking claim that his paper was 'an attempt to prove the existence of the Devil':

The mingled absurdity and bigotry of such an undertaking in the twentieth century, in the very flush of the age of

scientific enlightenment, will perhaps seem less striking if one considers the vagueness that prevails in our views with regard to the gentleman whose existence I desire to demonstrate. For just who is, what is, the Devil?
(Lanz, 1936, p.492)

This at first seems an odd theological occupation, even for 1936. However, rather than dismiss the Devil as a collective noun for a whole range of past superstitions, Lanz instead identifies its 'vagueness' as a constitutive aspect of its activity, which places it firmly in the modern age. Thus, to prove the existence of the Devil, Lanz suggests we recognise that the Devil is a 'surface phenomenon'; 'one-sided, only skin deep, with no real background – aimless evil'. But – and here is the clever twist – 'aimless and idle talk is gossip' (p.492). Hence, the point of his paper, entitled 'The Metaphysics of Gossip', is to argue that the phenomenon of idle chatter should be seen as an ethical affair: not only because it often involves pointing out the rights and wrongs of other's actions, but more importantly because the language of gossip refuses to be drawn into narrative or teleology – it is carried by slowly mutating repetition – and thus remains, in Lanz's words, a 'malady' of our age (p.496).

As far as I'm aware, the Devil does not exist. But the demonic, as a cultural phenomenon, has a long history in the pursuit of truth and the medial route to it. Lanz's alignment recasts this tradition into a relationship between the demonic and the apparent banality of the 'surface phenomena' of modern culture. This relationship was articulated some 40 years later by Anton Zijderveld (1979), whose sociological study draws heavily on Walter Benjamin's concept of aura in order to link a particular type of repetition in social interaction – banal idiom, and the cliché – to secular society's loss of a fixed sense of authenticity or legitimacy which religion once provided. Aura, for Benjamin, characterises a work of art's uniqueness (they cannot be

reproduced), distance (they are always above or beyond us), and permanence (they transcend the immanent world); all these in combination produce an aura. Each of these is dismantled by the mass mechanical production of the artwork as, say, a poster or postcard, which renders it no longer unique, easily available, and it can be destroyed as and when we please. The age of mechanical reproduction is transient and incomplete, a series of points that speak only to the present, reproduced in fragmentary and indistinct ways. Following this logic, Zijderveld argues that modern society has become clichégenic. In the absence of religious ritual, icon or cosmological destiny, we have malleable and ultimately facile points that adapt perfectly to the consumerist demand of capitalism. Meaning is reduced to function; in this sense, Nietzsche's seismic claim that *God is dead, and we have killed him* is a foundation of modernity not because of its literal deicide, but rather because, as a quotable tagline, it circulates and disseminates more readily around all kinds of discourses. Such an association between cliché and tyranny has, of course, been pressed to the point of over-familiarity; expressed across an entire spectrum of ideas and ideologies, from Clement Greenberg's 1939 essay on 'Avant-Garde and Kitsch,' to Jonah Goldberg's book-length assault on liberalism in 2011, and many more in between.

If function without meaning points to the dumbing down of both politics and ethics – clichés are, after all, typically seen as shorthand, thoughtless phrases – then we should also note that this collapsing of the motifs of evil into repetitive banality is intrinsically linked to changes to the conditions by which they have traditionally been persuasive. The Western demonic traditionally emerges in the victorious wake of a divinity, a god-king, a Cartesian rationalist, a romantic hero, and so on. Zijderveld's 'clichégenic society', however, renders this ultimate good as no longer restricted to the triumph of a singular or absolute reason, or innocence, or 'hypermoralization' (Forti,

2015, p.178). Instead, the appearance of such an ultimate good – where belief coincides with truth – is predicated on its persuasive use of *repetition*.

Analysing figurative language in Western culture, Sarah Spence argues that while the stylistic element of anaphora was once used by rhetoricians as a point of emphasis, it has now 'migrated from superficial ornamentation to deep structural principle...It provides a glimpse of what differentiates our era from all others' (2007, p.19). The rhetorical principle of repetition is, Spence argues, the 'embedded trope' of the late-modern age: rolling news, hashtags and re-tweets compress, carry and shape the binding truths of our time *by virtue of* their repetition, not in spite of it. Rather than destroying the aura of sincere or authentic experience, as Benjamin described, such repetitions create and maintain authenticity in ways that are both negative and positive, destructive and creative. Spence points, as an example, to the 9/11 Commission Report, which documents how it was only the crashing of the second plane that authenticated the first; it was only the repetition of the unthinkable that confirmed the singularity of the event itself. In this way, 'the second event has come to validate and identify the first, not the other way around; without the second the first is often misconstrued' (Spence, 2007, p.33). Far from the destruction of 'the event' that Zijderveld prophesised, the singularity of an 'event' is never quite enough when it is necessarily predicated on anaphora. The ultimate good, which supersedes the demonic, instead depends for its claim to be 'ultimate' on enthymemes of repetition and amplification. In his work on the disappearance of rituals which echoes Zijderveld's analysis, Byung-Chul Han notes:

Symbolic perception is gradually being replaced by a serial perception that is incapable of producing the experience of duration. Serial perception, the constant registering of

the new, does not linger. Rather, it rushes from one piece of information to the next, from one experience to the next, from one sensation to the next, without ever coming to closure. Watching film series is so popular today because they conform to the habit of serial perception...it does not establish relationships, only connections.
(2020, p.7)

For all its anachronisms, then, Lanz's paper turns out to ask an important question as to how the decisive moral tropes of 'evil' can be carried and shaped by the repetitive power of gossip. It is a question which prefigures what was seen in the twenty-first century when, for example, the news of Osama Bin Laden's death was broken over Twitter, announced simultaneously by a White House security expert *and* a former World Wrestling Entertainment star turned film actor (Stelter, 2011; Dwayne 'The Rock' Johnson's tweet remains viewable at https://twitter. com/TheRock/status/64877987341938688). Repeated images are both formative and effective in their representation of evil. It is a phenomenon I was struck by when there was a terrorist attack in Paris on 13 November 2015, and for several hours the rolling news coverage repeatedly showed the same, otherwise harmless clip of a van turning into a closed street. Here, repetition both carried the event necessarily ('breaking news' is premised on a recurrent headline) and affectively (the repetition of the scene itself, which was perfectly mundane, only heightened the suspense around what was not being shown, or allowed to be shown). It was not an overwhelming flood of information, in the sense that media critics often invoke, but the banality of evil captured in the simple act of a repeated scene.

Repeating ourselves

What to do with this? The real point of interest about Lanz's paper, for me at least, is precisely why his argument *fails*: the

point at which he tries to move past the banal repetition he cites as the Devil. While his conceptual starting point is the Devil, such signs, symbols and figures of individual demons are not identical to the dialectical performance of the *demonic* as a concept. In *The Interpretation of History* (coincidentally, published in the same year as Lanz's paper) the theologian Paul Tillich argued that if the demonic 'has not yet become an empty slogan, its basic meaning must always be retained: the unity of form-creating and form-destroying strength'. (Tillich, 1936, p.81) This unity distinguishes the demonic from the Satanic, the latter being a mere 'destructive principle, inimical to meaning'. To take a form is a creative act; this simple distinction between form-creation and form-destruction comprises the basis of the demonic as a creative power. Hence, Tillich noted that in his own time, the demonic finds a reality in the capitalist free market, and that 'last great demonry of the present', nationalism (p.133).

In this way, Lanz's identification of a *sign* – the Devil – immediately diverts his attention from the question of the *surface itself*; and more specifically, the medial form that carries this surface, and how such surfaces interact and interconnect to create the appearance of meaning. Instead, a focus on the demon (in the singular) leads Lanz down what remains a familiar route: an identification of a moral cause, the demon-as-other, and subsequently an analysis focusing on *difference*. Consider, for example, how works as diverse in content and aim as Cohen's *Folk Devils and Moral Panics*, Rogin's *Ronald Reagan: The Movie and Other Episodes in Political Demonology*, or Owen Jones' *Chavs: The Demonization of the Working Class*, all nevertheless deploy the figure of the demon in a similar commonplace position: representing an Other which is threatening but ultimately servile, even ridiculous; the pantomime 'devil' character, who audiences take pleasure in booing from the stage. Clearly, this Othering is a core part of Western demonology, and its form is

present in the moral calling to denounce stupidity that Ronell identified earlier. But the emphasis of this figure on difference (chronological, topological or cultural) fundamentally diverges from Lanz's initial conception of gossip (that is, the phenomena of circulated same-ness and medial repetition). This becomes a problem because of its subsequent effect on critique; in particular, a secondary 'othering' which often accompanies the demon-as-other commonplace. The act of exposing the dichotomies of 'good' and 'evil' contained within the sign of the demon necessarily seems to invoke its own dichotomies of rationality and irrationality: in this case, between intellectual critique and the passive consumption of modern demons.

Consider as an example Douglas Kellner's comments on the aftermath of 9/11:

The discourse of good and evil can be appropriated by disparate and opposing groups and generates a highly dichotomous opposition, undermining democratic communication and consensus and provoking violent militaristic responses. It is assumed by both sides that "we" are the good, and the "Other" is wicked, an assertion that Bush made in his incessant assurance that the "evil-doers" of the "evil deeds" will be punished, and that the "evil one" will be brought to justice, implicitly equating bin Laden with Satan himself. (Kellner, 2004, p.47)

Here, Kellner critiques the reduction of post-9/11 discourse to simplistic dichotomies of 'us' and 'them', using these to highlight how the resurgence of crusading terminology and Just War re-invokes the Oriental demons of old. At the same time, the force of his criticism leads to another reduction in the name of criticism itself: that is, one dichotomy (the creation of a good 'we' versus evil 'Other') is replaced with another (the active critic of this dichotomy, and its reactive consumer). A

more recent example can be seen in the way that the enigma of Trump has been discussed in terms of the idiocy of the masses. For example:

> Trump's phenomenon is a psychological manifestation of the particular mass constituted by his followers. This mass's libidinal investment in Donald Trump is an effect of a hypnotic-like suggestion that he, as a leader, exerts on his followers. As such, they follow him by means of an identificatory process of love.
> (Fernandez, 2017)

Trump's popularity, on this reading, is produced via a form of psychological neurosis, which has the effect of allowing the fantastical (for example, the many dubious claims Trump made about his health, his accomplishments, his sexual prowess and so on) to become a meaningful sign. As a result, the fantasy element within the interpretation of Trump serves both the poetical critique of his supporters (invoking zombies, cult worshippers, and all the other popular tropes of the crowd), but also enables a clear disdain for allowing fantasy to enter politics at all:

> The libidinal bond of the masses, as most imaginary love, is idiotic because it is trapped in an enjoyment of the individual's own fixed narcissistic image reflected and therefore embodied in another: their leader Trump. Similarly to the way one enjoys celebrity gossip, the masses enjoy vicariously through the figure of their chosen leader. Frustrated and suffering the effects of years of dispossessing neoliberal practices, Trump's supporters position him as an ideal, a compensatory image of themselves projected into a fantasized future. (Fernandez, 2017)

The results are a curious double-bind: on the one hand, the enjoyment of celebrity gossip is acknowledged as a force of immense political persuasion, which is also somehow illegitimate or stupid (even though it produced an elected president). On the other hand, the sober and realistic view of the intellectual is underwritten by a similar enjoyment of the analyst: a diagnosis of psychological disposition for an individual, which provides understanding and closure on the matter. The problem is that this diagnosis must *also be imaginary* because the individual diagnosis is, without a pause for mediation, projected into figures of the mass crowd – 'followers' and 'supporters' – who do not, and cannot, exist *as* individuals.

This move is also seen in Lanz's proof of the Devil, whereby he concludes that 'good' and 'evil' are appearances, not ultimate realities. As *appearances*, it is 'the artist' who can magnify the slipping of one into the other once they are embedded within idle chatter. For when gossip 'becomes artistic, far from degrading art to the level of mere chatter, it raises it to Olympic heights' (Lanz, 1936, p.499). In other words: in the hands of the *expert* (the artist, the critic, etc.), good things may come. Yet, the nature of these good things – that is, what is actually 'good' about them – already seems to go beyond the initial sense of good as a 'mere appearance'. There is a complex repetition at work which underlies this re-introduction of the 'good'; a repetition obscured by the focus on the production of signs rather than their repetition. In this sense, the problem with the use of devils, the wicked, or the dangerously stupid as rhetorical motifs is the excessive amount of *clarity* that these figures lend to what is, in reality, a rather muddy field saturated with multiple visual and cultural references. As Forti rightly argues, we are no longer in what she terms 'the Dostoevsky paradigm' regarding the problem of evil: '*wicked demons* on the one side and *absolute victims* on the other', based around the 'desire for and will to death' (Forti, 2015, p.6). Instead, Forti argues that such a

paradigm of absolutes must be replaced by an understanding of 'mediocre demons' (p.9) that, far from being 'ultimate', are far more replicable and, as such, banal.

In this way, Lanz is entirely correct to situate the demonic within the circulation of gossip. However, he also maintains an attempt to reduce the demonic to a motif of difference – 'irrationality', 'other', etc. – and thus frames gossip as straightforwardly antithetical to proper thinking (when outside of the hands of experts, at least). The simplification of the demonic to one, destructive meaning overlooks the creative role of simulation and repetition that gives the demonic its specific, and persistent, effect across its cultural history. Such a creativity is not reducible to the production and exchange of signs but is rather embedded within the *preservation* and *circulation* of signs: that is, to borrow Forti's terms, the mediocrity of communication. It is this mediocrity, I think, that drives the relationship between a politics of sincerity on the one hand, and evil on the other.

The two deaths of Osama Bin Laden

This mediocrity is perhaps exemplified with the aforementioned death of Osama Bin Laden. The figure of Bin Laden in Western media shows how, despite scientific enlightenment and multiple secularisation theses, demons very much occupy the twenty-first century Western imaginary. As a devil, Bin Laden calls forth apparitions of the oriental/occidental divide; narratives of past crusades raised and re-raised from the dead, metamorphoses from freedom fighter to terrorist, and images of the classical Termagant figure in curious juxtaposition with emerging medial technologies. Both aesthetically and rhetorically, Bin Laden was an exemplar devil and, as such, is immersed in unwieldy relations of myth and narrative surrounding the figuring of difference.

I want to pick up on a very small part of this narrative: not

the fact that Bin Laden was killed, but that he was killed (at least) twice. The two deaths emerged from two official reports of the event; on 2 May 2011, the White House counter-terrorism adviser John Brennan gave a relatively detailed, and immediate, account of the death; the next day, White House press secretary Jay Carney presented a different narrative. In the first, Bin Laden's wife had been killed while being used as a human shield by the armed terrorist, and the Navy SEALs were instructed to take him alive if possible. In the second, the wife was only injured, having rushed at the SEALs, and it was not clear – and highly unlikely – that Bin Laden was armed himself.

The first, and perhaps most obvious, reading of this is that one death simply corrected the other. The initial report was inaccurate, so the second report corrected, explained or admitted ambiguities (certainly enough for some to question whether President Obama's claim that 'justice has been done' was wholly legally justified). If we focus on the truth of the matter, or the clarification of facts, or the nature of justice – if we treat this as an epistemological or moral issue – then we remain in the domain of difference. There is no repetition, as such; just the bringing to light of all the known facts.

A second possible reading is that this double announcement simply re-asserts the conventional wisdom that the demonic only has meaning at all in terms of its ultimate overcoming by the powers of the divine; but with the added caveat that, since the death of God, the conspiracy theory is the only metaphysical certainty we have. The absence of a body would always fuel such a reading: but conspiratorial readings still insist on a linear narrative unity, whereby a threat is presented and overcome; the demonic scene becomes a signification of demons. In Tillich's terms, this still emphasises the destructive aspect of the demonic at the expense of the creative.

The real interest of the absent corpse was the deliberate removal of a sign or symbol of the death, meaning that the death

itself directly opened a question of what Boris Groys terms 'sub-medial suspicion'. Epistemology and morality concern the exchange and relation of signs on the medial surface. But, Groys notes, signs necessarily block the medial carrier, which also sustains them. Sub-medial space thus remains a 'dark space of suspicion, speculations and apprehensions – but also that of sudden epiphanies and cogent insights' (Groys, 2012, p.13). The sub-medial subject is not one of knowledge, but of fear and suspicion. The ontology of media, then, is not about the correspondence of signs to truth, but medial sincerity: that is, how much we trust in the carrier of signs. While suspicion, in this sense, 'is generally considered a threat to all traditional values', (p.173) it is for Groys 'not a subjective attitude of the observer that can be changed by force or will; rather, it is constitutive of the very act of observation as such. We are unable to observe without becoming suspicious' (p.174). As such, the more we believe that we have uncovered the medium of a message, the sincerer it seems. This is only ever fleeting; for, just as flipping over a painting reveals the canvas behind, once the sub-medial becomes visible, it becomes a sign and consequently is supported by its own, hidden, sub-medial space. We cannot see the two at once: we are thus, Groys suggests, 'always already involved in the economy of suspicion, which is, so to say, the medium of all media' (p.175).

In this sense, there is something within the repetition of Bin Laden's deaths which embeds the scene within the broader history of the demonic, and the distinction between good and evil, as a cultural form. This link is the sense in which the sincerity of the event itself was created in this act of repetition. With all else that surrounded the figure of Bin Laden – whose effective power of 'terrorism' went well beyond bounded acts of terror and was maintained through the aesthetic means of emergence within networked media (both of his own production, and of those who fought him) – for his death to be 'authentic', there

had to be some kind of a cover up, some kind of error, some form of unreliable report. One act could not be enough: for with the perpetual possibility of alternative accounts and iterations – images, documents, feeds, etc. – medial sincerity is only really achieved once a report has been first rendered suspect, and then repeated. The sincerity of the single event is premised on the metamorphosis of its own repetition; a repetition which assures both that the demon has been eliminated and that their initial suspicion was warranted. The audience has, in effect, seen the event for themselves, but only by seeing the undoing of that event in terms of its sub-medial conditions. At this moment, when these two deaths exist within the same medial space, the laying bare of a cover up assures a sincerity to the event that it would not otherwise exhibit. It gives the two deaths one life, rooted in the trust that some event had happened; establishing the trust needed to move forward and explore what kind of event it, in fact, was. It also provides a specific sincerity to the event, which allows the audience to move onwards into the arrangement of signs and figures, books, films, conspiracy theories, and so on. For, as Groys notes:

> suspicion supports all values medially, because submedial space (the submedial carrier) is nothing but the space of suspicion...However, in order to be truly compelling, values must repeatedly renew the mana of medial sincerity. That is, they must repeatedly confirm the suspicion that submedial space "essentially" looks different on its inside than it appears to be on the medial surface.
> (Groys, 2012, pp.175-6)

In Groys' view, such 'mana' – the 'aura of medial truth' – is renewed by the act of critique: after all, the attempt to expose or reveal what is hidden within a sign is also a demonstration that something exists behind it. Critique is thus embedded within

a cultural economy which involves not only the exchange of the surface of a sign for a hidden sub-medial 'reality', but the generation of a value in the original object of critique: as Groys notes, 'the more a sign is deconstructed, exposed, stripped of its aura, and devalued, the more mana and medial power it absorbs'. (2012, p.165) What is apparent, though, is that the two deaths of Bin Laden present something distinctive from this general economy. It is the doubling of the event – the anaphoric repetition, rather than the economic supplementing or substituting – that lends it sincerity.

In this sense, the fleeting scene of Bin Laden's two deaths passes quickly precisely because it is embedded within particular techniques of iteration that are otherwise completely banal. The question, then, is how these technologies of repetition, embedded within the banal repetition of our everyday practices, might not only sustain a paradoxical 'life that is opposed to life', but also sustain an equally paradoxical death: or at least, blur the difference between authentic and replicated death for the sake of medial sincerity.

White Bear and weak finishes

The double announcement of Bin Laden's death creates an event explicitly through the circulation and repetition of information. Sincerity, in this case, is produced not simply by locating a source of 'truth' – such as a proper reference, or an absolute relation to the event that we observe – but rather through the awareness of where we, as interpreters, stand in relation to repetition, or, more specifically, its inherent errors. As such, the repetition of an event identifies and validates its originality on the one hand; and on the other hand, by virtue of this possibility of repetition, the very vulnerability of that truth is exposed. In other words: there is no sincerity without chatter.

In his detailed account of the 'narrative turn' in Western politics, Christian Salmon provides a powerful insight into how

policy decisions are replicated – and then replaced – through the perpetual repetition of the 'enigmatic signs' of storytelling in order to project an authenticity to a disillusioned voting public. But this turn, Salmon argues, is prompted by a specific problem facing political speechwriters and spin doctors regarding the everyday, aimless circulation of something which Lanz might recognise as gossip: 'How can we control the explosion of discursive practices on the Internet? How can we communicate in this chaos of fragmented knowledge without the help of some shared legitimizing figure?' And, in turn, 'How are we to describe the conflicts of interest, the ideological or religious collisions, or the culture wars?' (Salmon, 2010, p.94). This is why, Salmon argues, 'storytelling has become the "magic" formula that can inspire trust and even belief in voter-subjects' (p.95). In this sense, the coherence of political storytelling – which would include the conspiracy theories which by now envelop Bin Laden's two deaths, in the way that they clumsily force the visual *mythos* of the Bin Laden trope into a scientistic causal logic – creates trust *only* by building on a prior sense of sincerity already embedded within the flow of that which it attempts to control. Necessarily, this narrative resolution is weak, simplistic or overly-clear for the complexity of the depth of rhetorical signifiers it draws on. As such, while it is tempting to apply a heavy-handed coherence to the scene of Bin Laden's death – to insist on one death, not two – doing so effectively enacts the same rhetoric of control which Salmon criticises. It insists on one narrative over another, without probing the conditions by which we trust in either. Likewise, though, it is not enough to simply critique this narrative turn for what Salmon's book describes as the 'bewitching of the modern mind'. This only serves to obscure the question of how the critic themselves accesses such narratives yet remains *un-bewitched*, or what happens to the circulation of bewitchment once it is exposed. And in many ways, such an obscurity – an obscurity which is

paradoxically produced from the very act of critical clarification – serves as a contemporary form of demonic temptation.

One more illustration of this before we return to the question of parrhesia. In 'White Bear', an episode of Charlie Brooker's television drama series *Black Mirror*, a girl, Victoria, wakes up with complete amnesia in an empty house in an abandoned village. Exploring her surroundings, Victoria is soon pursued by a slow-moving, zombie-esque crowd who silently film her on their mobile phones. In fear, she is taken into some woods by a mysterious saviour, who then attempts to viciously torture her; as she calls for help, a mute audience gathers, continuously playing the scene on their mobile devices. But before long, the reveal is made: the set is pulled away, and we see that Victoria has unwittingly been caught in real-world play. The mobile phone carriers are a paying audience, and the characters she has met only actors. Strapped to a chair, the narrative is resolved: Victoria is not a victim, but in fact a perpetrator; years ago, she participated with her fiancé in the abduction and murder of a child, which she filmed on their mobile phone. Having pleaded guilty while claiming to be 'under the spell' of her fiancé, her punishment is confinement in a lurid theme park named the White Bear Justice Park, where each day members of the public can pay to enact a curious mob justice: she is forced to undergo the same experience of terror which the victim felt, and in this way is exposed to her crime (and punishment) in front of a baying studio audience. She is then drugged, awaking the next day with no memory; caught in a constant loop of re-discovering her crimes.

Characteristically for *Black Mirror*, 'White Bear' plays on the audience's expectations through the archetypal arrangement of hero and victim in zombie movies, switching one demon (zombie-turned-audience) with another (hero-turned-child-killing-voyeur), in order to open an implicit question over the morality of the distant, disinterested spectators who thirst for

the visceral and imminent punishment of unthinkable crimes (audience-turned-zombie again, perhaps). In doing so, it reminds us that the recent cultural resurgence of zombies is only ever nostalgic. The zombie may be undead, but such a traversing of life and death is far from a *demonic* monstrosity: in archetypal series such as *The Walking Dead*, the eponymous undead are still markedly *different* from those who are alive; the fear they elicit is blunt horror, rather than uncanny (this is precisely why the case of intelligent zombies in *Army of the Dead* and *Redcon-1* introduce difference so bluntly and awkwardly). In contrast, 'White Bear' reminds us that the creative aspect of the demonic, as a medial form, fundamentally problematises such distinctions. Indeed, the central demonic aspect of the episode is the constant repetition of the action by the ever-present 'screening' of mobile devices.

The very moment at which this uncanny repetition is removed – the moment when the twist is explained by an announcer on a stage, at which point the ambiguous juxtaposition gives way to a moralising narrative – this demonic aspect subsides and is replaced with something more like a folk devil (Victoria herself). It is not insignificant that the 'reveal' of the episode is purposefully weak – performed with the camera uncomfortably close-up to the announcer, straining to express the moral disdain at the protagonist's past actions. The single statement of sincerity – *this* is what you have been watching, *all along!* – is rendered feeble by its removal and obscuring of the different medial surfaces on which it rests. That is to say: on the one hand, we are being shown everything there is to see regarding the plot narrative; but on the other hand, the very power of the narrative was our suspicion that there must *always be more*.

This means that the use of repetition in 'White Bear' – of images, of names and of genre tropes – is central to the sense this use of narrative creates: to such an extent that, once a narrative resolution emerges, it can only ever be weak. The

moment in which the meaning of the event emerges, removing the repetitive aspect, the strength of sincerity dissolves. We are once again reminded that the singularity of the event is not enough, if it is to be sincere. Instead, the repetition of the event reveals a sincerity which can only ever be paradoxical.

In both fictive and real senses, 'White Bear' and the aftermath of Bin Laden's death stand as a key illustration of Bruno Latour's charge that cultural critique and conspiracy theory are not so far apart. It is tempting, likewise, to figure the rhetoric of 'ignorance' or 'evil' as separate from its sub-medial structure when, in fact, the medium of communication is precisely where the creative terror resides. It is just as tempting to place it, as Salmon does, within a 'fiction economy' (2010, p.53) that is based on nothing more than the production of storytelling, rather than the circulation and preservation of such narratives which are embroiled within the cultural discernment of the medial from the sub-medial. And, of course, it is true that in 'White Bear', as much as in Bin Laden's demise, there is a question of 'what *actually* happened?' which demands an answer beyond the ornaments of anaphora. Of course, there are ethical and political questions which follow from the 'facts' of the answer to that question.

It seems that these questions, important as they undoubtedly will be, are not answered by reducing a scene to its sincerity, to a core 'truth to power'; instead, the moment that truth *speaks* to power resides in the medial repetition of surface phenomena. The power of parrhesia, of speaking the truth within a space of public discourse which is always-already susceptible to irony, lies precisely in its capacity to repeat and mutate – that is, to communicate – rather than its underlying sincerity alone. This is precisely why viewing post-truth as a kind of procedural error that can only be corrected by a healthy dose of more of the same, rather than as a natural evolution of these same principles in a world of mass information and communication, continues to

unhelpfully reify certain concepts – in this case, the alignment of the good and the intelligent – in an inherently ironic political sphere where such concepts struggle to be sustained without structures of power and rhetoric supporting them.

Boris Groys once wrote that after the death of God, the conspiracy theory is the only metaphysical certainty we have. He need not be referring to the extreme conspiratorial views – that there is some kind of worldwide cabal orchestrating natural disasters, be they capitalists, liberals or aliens, etc. – because the observation manifests itself in a far more mundane way in much of today's public discourse. On seeing turkeys voting for Christmas again and again, this suspicion grows to suggest there is something *more*, something behind the surface which, *if we could only see*, we would be able to combat; while at the same time suspecting that there is, in fact, nothing more, and the very exercise of critique is useless. We must, then, simply restate our positions in a fundamental 'against-ness' (Felski, 2015). There is both a moral imperative to speak, and a frustration at not finding what to speak about – at least not in the places one expects them.

How, then, do we speak the truth to stupidity – especially when the persistence of the trope of stupidity suggests at least some clarifications are needed concerning how we arrive at that truth? Underlying all the scenes we've discussed are fundamental – albeit fleeting – questions about how medial sincerity maintains, in uncanny ways, the same tropes of moral and critical teleology that would seem otherwise opposed to it. The sincerity of Bin Laden's death is not achieved through the production of the event, but rather through the *expectations* of its circulation: specifically, expectations of error and counter-narrative that are nothing other than the heightened economy of suspicion that drives, in Groys words, the medium of media.

This brings us back to Lanz's problem of gossip. It is not that gossip completely withdraws from any narrative economy of

signs. Rather, it circulates an uncomfortable *excess* of signs; the mundanity of which are always slightly beyond the grasp of definitive concepts.

Such an excess is often described in terms of the 'overwhelming' chatter on the internet, the 'flood' of information and the uncontrollable sprawl of data: all distractions from or enemies of sincerity, truth or authentic understanding. But the more basic point is that positive parrhesia is committed to employ it to an extent. It must exceed the narrative economy that it is presented with, otherwise it has nothing 'true' to speak to power. This necessarily involves banal aspects that linger on the surface of medial interactions. Attempting to put to one side the banality this brings with it poses a risk of losing the ability to tell the sub-medial from the medial, and investing instead in a sincerity based on an endless interplay of surfaces.

Chapter 6

It All Comes Down to Interpretation

I began this book in the time-honoured fashion of raising a problem. In a similar fashion, presenting a solution will always seem a little bit disappointing. After all, how do we get away from rhetorical deployments of 'the stupid' and towards the concerns about knowledge, without replaying the same tensions within the idea of intellect that led us here? Or more broadly: how do we move beyond post-truth without invoking the same ideals of truth that let it develop? If I suggest here that, ultimately, the problem with 'stupid' all comes down to interpretation, this risks sounding like naïve relativism, or some bastardised form of postmodern sophism. Indeed, from the rise of behavioural science to the return of the 'scientific method' in the response to post-truth, from the strategies to address fake news with brute certainties to the jibes regarding 'alternative facts', the significance of interpretation is not always an easy point to push. But what I have tried to show throughout the previous essays is how the deployment of stupidity within public debate has obscured many of its interpretative conditions. Or to put it another way: it seems to me that without taking account of how these communal understandings mediate our interpretations of the stupid, even the most well-intentioned responses to problems with stupidity can end up only exacerbating the problem.

Consider the following meme:

Do y'all remember, before the internet, that people thought the cause of stupidity was the lack of access to information? Yeah. It wasn't that.

The claim is familiar, even obvious: the array of information promised to be 'at our fingertips' in the digital age has turned out to be counter-intellectual. Across varied critical traditions, we find similar claims that an 'overwhelming flood of information' (Haack, 2019, p.265) leads to 'the drowning of meaningful experiences in a sea of random noise' (Terranova, 2004, p.14), bombarding our faculties and leaving us unable to distinguish meaning from non-meaning. James Bridle referred to this as a 'New Dark Age' where 'the value we have placed upon knowledge is destroyed by the abundance of that profitable commodity, and in which we look about ourselves in search of new ways to understand the world' (Bridle 2018: 11).

Dark times indeed; and on the one hand, the meme is absolutely right. Access to information would *never* be a cure for stupidity, unless one continues to caricature knowledge as something one simply picks up and secures (as I discussed in Chapter Two), ignoring the socio-political interpretative relationships that govern the limits of ignorance. On the other hand, the meme is obviously not arguing this, and it would be less amusing and shareable if it was. It's simply pointing out that the access to information is being misused by stupid people (whether this is their fault, or the fault of the internet); while deploying a form of nostalgia for a kind of lost modernity (remember when we had hope for the general intellect?) which seems to make a habit of accompanying declamations of the stupid.

This notion of 'access' not only frames the idea that public debate is overwhelmed with the noise of information (too much access, not enough critical thinking), but also the solutions on offer to redress the conflicts raging over who is stupid and who is not (which typically takes the form of yearning for the 'gatekeepers' of truth to return and organise the easily-led). On this note, I find the metaphor of water intriguing in the examples above: it implies a uniformity to digital circulation,

as if users are as unable to tell the difference between one ocean wave and another as they are between Wikipedia and the Death Clock, or between *The New York Times* and a Flash game of Tetris. Of course, there is a sense in which the importance of circulation itself overrides individual content (as Jodi Dean has argued in *Blog Theory*). But my interest remains in articulating the interpretative spaces and situational curation that enable the irony of digital media to retain its sense and its authority. It is these, after all, which provide the sites for moving beyond the cynical deployment of 'the stupid' in public discussions.

'Access' in this sense does not simply concern a threshold or entrance, but instead how communal understanding, or interpretative horizons, are formed, associated and disassociated. This is, of course, part of the fundamental principle of hermeneutics, the art of interpreting and understanding multiple meanings within the 'communicative interactions of plural forces' that Otobe described in Chapter One. But another part of this is the way in which understanding is mediated – in other words, how 'the stupid' or stupidity itself are curated within our interpretative horizons – not simply by linguistic affects, as Marazzi and Berardi raised in Chapter Four, but also through the involvement of a range of commitments and complicities that may go beyond language in the conventional sense. When I suggest that it all comes down to interpretation, this is to say that it comes down to how we deal with these commitments and complicities: mediation that is not just linguistic (as hermeneutics has traditionally focused on) but also procedural and curative.

Triggered

In *Spoiler Alert*, Aaron Jaffe describes the connectivity of the digital age as a hardwired 'compulsory regime of stupidity'. (2019, p.5) But unlike those who see this regime as a succumbing to some kind of Debordian fantasy of ceaseless

empty spectacle, Jaffe understands that the stupidity of this regime is not a simple reversal of what progressive modernity once imagined itself to be. Instead, he suggests that the view of an insurmountable volume of information frustrating any attempts to distinguish the 'useful material from the dreck' (Haack, 2019, p.265) becomes itself an idealist fantasy, and furthermore a fantasy which is rendered difficult to sustain by the figures of the spoiler and the trigger. These present a more complex relationship between sense and narrative: in particular, the framing narrative that digital information is an *indiscernible* flow of noise, what Habermas once bemoaned as disrupting the 'intellectual focus' of modernity (see Keen, 2011). The spoiler and the trigger (the latter is, Jaffe argues, the reverse-wiring of the former), far from a retelling of a narrative or issuing a causal sequence of significant events, are 'a switch, a flop, a knee jerk, an impedance mechanism made operational for a connected world charged with specific knowledge sequencing problems'; less a *precis* and more the signal of a 'new technical sensitivity to activated sensibilities' (Jaffe, 2019, pp.3, 13). In a regime where information is always-already available, the spoiler alert 'encloses a world' that is 'supersaturated with tacit, nondisclosure agreements...we simultaneously didn't agree to and acutely experience as betrayals of virtuous stupidities' (p.4). In this way, rather than embody the threat that the excesses of the information age pose to the intellectual, spoilers and triggers bring to the fore the various complicities at work in how such excesses are organised and engaged with. In this way, they operate as a distorted mode of critique which unsettles the assumptions that we are in a constant state of overwhelmed cynicism marking, for Jaffe, a shift in the 'critical quality' of modernity.

The sudden appearance of terrible future knowledge seems to confound present stupidities from all directions. This

platform that is alarmed – altered and warned – has means and agencies. More circumspectly, they are the technical side effects of the enormous capacities of storage, information readily available at bargain-basement prices, well before our current moment.

(Jaffe, 2019, p. 22)

Where there is an enormous capacity for readily-available storage, there is also necessarily a task of curation: a task which necessarily incorporates questions of access, preservation and value.

The spoiler and the trigger are, of course, part of this curating act, and the latter is a particularly pertinent aspect of the form of procedural polarity across social and print media, known as the 'culture wars'. Once framed by James Davison Hunter as an irreconcilable face-off between progressives and traditionalists, this polarity is now a well-established mode for translating complex issues into simple behavioural schema regarding access and visibility. Such a procedure means identifying behaviours that perform for or against one pole or the other: a vote, a tweet, a public statement, an off-the-cuff remark. The dominant term for addressing such behaviour is 'cancellation': from a Middle English term 'to cross out with lines', which of course means that, unlike deletion or destruction, whatever is cancelled will always be partially visible, and thus never really disappears in the way the self-proclaimed victims of cancellation might claim that it does. It is not a question of access in the straightforward sense; after all, we can all see that an event was meant to take place, or that a person was meant to have tweeted. It is far more a question of association – in all the different ways this takes effect. It is a prime battleground for intelligence, involving not just what Miranda Fricker might term 'epistemic credibility' – the persuasiveness of the knowledge underlying an offence taken by either progressive or conservative groups – but also

campaigns against perceived ignorance and seeks to change behaviours as a result.

I call this a procedural polarity because it increasingly turns out to be a sense-making frame rather than a set of instinctive concerns. An IPSOS Mori poll in 2021 suggested that three-quarters of the UK population thought public divisions were exaggerated, and just under half felt politicians over-emphasised 'culture wars'. Whether or not anybody has actually been 'cancelled', and to what extent cancellation is a violation of rights or a badge of honour, there remains a procedural structure of adversity. Furthermore, the heuristic performance of the trigger is often obscured by such a polarity: in other words, this constitutes a form of sense-making even before any content or arguments have been produced, the persuasiveness of which may well be linked to developments in access to digital technology and social media, but also maintains a nostalgic grip on dualisms of the past – meaning and senselessness, resistance and subservience, etc. – for its energy and fury. Hence, Ben Burgis notes that while cancel culture has come to signify a 'cluster of cultural trends that have different levels of impact in different parts of our culture', it has nevertheless subsumed discussions of mainstream progressive politics (Burgis, 2021, p.81). Key to this, as Jaffe has already noted, is an investment in stupidity: some form of inept-ness that leaves public discourse open to the risks of the wrong kinds of ideas; some form of ignorance pervading those ideas. So-called 'cancel culture' revels in identifying those in the wrong; in Mark Fisher's words, it is 'driven by a *priest's desire* to excommunicate and condemn' and 'an *academic-pedant's* desire to be the first to be seen to spot a mistake' (2013). Like the non-sequential disruption of the trigger, these desires present a scene of mutated heuristics: taking a position in the culture wars invariably involves the assertion of non-contingent truths within contingent flows of media communication. Sitting alongside cultural disputes is a

refusal to acknowledge the inherently ironic world of mediated performance. In this sense, the current 'culture wars' are less an entrenched opposition between two committed armies, and more a way of curating distinctions between 'self' and 'other', when drawing boundaries between the two is at odds with what Han terms the 'general promiscuity that has gripped all spheres of life' within late-capitalist globalisation (2015, 9).

Stupid democracy

This complicity between long-standing accounts of stupidity as a socio-cultural ill, the range of cures or gatekeeping drawn on to address them, and the ironic assemblages of digital media complexities, is significant. After all, as I have suggested earlier, the impact of triggers and cancellations can't be wished away with appeals to greater sincerity in public life, or a more authentic politics, alone; instead, the task is to understand the interpretative core of such complicity.

An opportunity to explore this in more detail came when, 30 years after first popularising the idea of the culture wars, Davison Hunter gave an interview to Zack Stanton entitled 'How the "Culture War" Could Break Democracy'. While there are any number of academics speaking and writing on the culture wars, Hunter's reflections are pertinent not just for their content, but for the historical reflection the interview performs on conflicts which depend so much on the storage of historical data: what someone once tweeted, who someone was once photographed with, how artefacts from the digital past can be re-presented in the present. At the same time, Hunter also returns time and again to a particular historical narrative, which can only ever end in cliché, and this points to the ways in which the commonplace of 'the stupid' is perpetuated; even in other, more aggressive, readings of the fate of democracy such as Shawn Rosenberg's theory of the 'incompetent citizen' (2020) or Hélène Landemore's account of the 'dumb many' (2017).

Over the course of the interview, Hunter tells a bleak story. The basic premise of a culture war, he argued in the 1990s, was that politics focuses on cultural issues: identity, history, education, and so on. This created a problem, because if an issue is political, it can be resolved through compromise. But if an issue is rooted in core moral beliefs which different sides see as 'truth', the issue will remain interminable. Politics today, Hunter argues, is underwritten by what people hold as sacred to them, and what they will defend beyond reason or evidence. As a result, this cultural aspect remains core to politics, but the development of media technologies means that we have 'doubled down' on the war, and its reach. In this sense, while Hunter does not build his argument on the figure of the stupid, as Rosenberg and Landemore both do, he nevertheless questions the competence of democratic participation in terms of the relationship between politics and culture.

Stanton's piece is instructive, not just for the way in which Hunter summarises his account of the culture wars, but also for the way in which it highlights the limitations such a narrative encounters. Three aspects are worth focusing on in particular.

First, Hunter notes how the relationship between the sacred and the profane dominates the logic of the culture wars. Hunter sees culture as a relatively rigid distinction between the two: each side of the war will feel that what they hold sacred is under attack – be this their gender identity, their racial history, their right to bear arms and so on – and will consequently fight to maintain it from what they see as an invasion of the profane. This is, of course, a core definition of 'identity politics' as a necessary consequence of the disintegration of cultural master narratives: the cohesion of what is 'sacred' in society is fractured, and the threat of profanity is thus felt everywhere.

Second, the defence of the sacred leads to the prominence of 'war' as a trope, and a way of framing the imaginary through which we view cultural aggressions and identity politics.

Talking about our differences in terms of violence leads to the potential for real violence (as would be seen on Capitol Hill in 2021). It seems clear that the prominence of a militaristic imaginary governing the culture 'wars' is a fundamental issue. This is also precisely why the standard liberal request for those on either side to just talk a bit more is so problematic. After all, what models, images and metaphors do we have for 'talking more' that can override the allure of militant triumph? It is far easier to draw on images of territorialised knowledge (what we can pick up and hold) and immunological defence against aggressors.

Third, the solution that Hunter arrives at for moving beyond all of this revolves on clichés. Because a sphere of discourse operates based on fleeting attention, its content becomes necessarily shallow. Those adept at dealing with short attention spans are able to reduce messages into soundbites and slogans – Make America Great Again and so on – which can then act as a cipher for any number of complex issues its audiences might wish to impress upon it (reminiscent of Zijderveld's clichégenic society). In drawing this conclusion, Hunter's answer turns out to be a collection of clichés which we've all heard before: we need to talk more; there needs to be better education; 'it's a question of attention', because social media destroys attention spans and allows only shallow thought and its users live in self-affirming bubbles.

I agree that these three aspects – culture, war and dialogue – are precisely the hinges to the hermeneutic issue at hand, and as such the ground Hunter covers (and has covered through an extensive career) is entirely pertinent. The difficulty arises when we consider the role of mediation. The endgame is very much a question of access: opening ourselves up to alternative and challenging views, supported by better education. But this is not the first point of mediation, or the first time access is contested. Indeed, the commitment to certain forms of

mediation, and particularly nostalgic ones, hamstrings the conclusion that better dialogue will move us beyond cultural conflict, post-truth or the problem with the stupid. At the same time, articulating these contested points allows us to rethink what 'moving beyond' would look like.

Memorialising the culture wars

For Hunter, culture is cast as a set of core, unchanging values of a community or society: culture and values therefore broadly equate. However, this equation tends to pass over the sense-making narratives that are (as Hunter rightly notes) key to the set-up of the culture wars. All of the binary oppositions which support his account – meaning vs non-meaning, democracy vs violence and attention vs shallowness – are only really persuasive *after* the event itself, as a kind of *post-hoc* framing of discourses initially flooded with ironies and pluralities. The linear narratives that Hunter chooses also begin at the end of the story: when meaning has withered into non-meaning, attention has decayed into shallowness and so on. Narrative is not simply a representation of division, in this way, but also a curation of conflict. In this light, the question at stake seems to be, not 'what to do about the culture wars?' or 'how do we prevent the culture wars?', but rather 'how do we memorialise the culture wars?'

The role of memorialisation is important. First, because one of the major sites of the culture wars throughout the late 2010s and early 2020s were public protests regarding public statues and monuments to slave owners and racial aggressors. Second, because the role of remembrance and preservation is, I would argue, precisely how culture *differentiates* itself from 'values'. Both of these aspects involve the role of the expanded archive – including the growth in storage capacity that Jaffe mentioned earlier – and the ways that this troubles the notion that to combat the stupid we simply need better understanding and a

closer attention span.

To make this point, I draw again on the work of Boris Groys. Groys argues that value cannot be equated to culture because the logic of cultural preservation demands the consistent *challenging* of what is preserved and what isn't. Every cultural work – be it a book, a film, an artwork or even an act of protest – is less a re-assertion of culture and rather an attempt at a revaluation of values, by engaging the concerns of what is not preserved, outside of the cultural archives (the profane), with what is stored within them, and therefore maintained beyond their original use (the sacred). It follows that this distinction between the profane and the sacred is necessary for anything new to be created, because standardly what is new is defined as something that is different from what already exists in the archive. If 'cultural values are nothing more than archived memories of events in the history of the revaluation of values' (2014, p.70), it follows that these will be necessarily limited to particular spaces and times. As such, what is new is always 'something valuable that a particular historical period privileges, assigning the present precedence over both past and future' (2014, p.30). In assigning such a precedence, culture insists on the value of particular differences over and above other differences, which are deemed to be culturally valueless.

While Hunter is right to situate the culture wars around disputes over the sacred and the profane, then, the cultural archive is not a structure for monolithic preservation, rigid and unchanging, but rather a system which is constantly changing its boundaries by virtue of what is not inside it:

Every time the border between the archive and reality is transgressed in either direction, we experience joy over the possibility that this border may now be suspended or deconstructed for good. Yet these transgressions instead confirm the stability of the border, which guarantees the

very possibility of such transgressions in the first place. (Groys, 2012b, p.30)

The effect of this is that this cultural economy ensures that differences are based on the same logic of archival comparison. Ironically, anything new is determined by certain differences being recognised 'because we already have the capability to recognise and identify this difference as difference...To recognise means, always, to remember.' But, as Groys continues, 'a recognised, remembered difference is obviously not a *new* difference'. (2008, p.28) In short, value cannot be equated to culture, because value is always subsequent to the archival logic of culture.

This highlights the significance of the extent to which dossiers on the 'culture wars' are so often positioned as memorials, as with Hunter's case: they are not a case of encountering a difference of opinion or a competing value system, but rather a case of remembering and curating. This is no better illustrated than in the protests over statues and memorials to colonial legacies and racial conflicts across the world, with attacks on representations of historical slave owners and the debate this ignited over the limits of protest. Lucia Allais described such a wave, drawing on Rosalind Krauss' famous reformulating of sculpture and landscape, as an 'expanded context' of archival impact:

This recent conflation of race wars and monument wars has thrust the US into a worldwide wave of heritage conflicts – a veritable 'territorial turn' – where disputes over monuments inevitably ooze outward to encompass entire parks, city centers, pilgrimage routes, etc., acquiring immense political valence and potentially devolving into revolution. Monuments serve as a dispersed cultural archive; their preservation involves control of nothing less than the

national narrative.
(in Dickerman et al., 2018, p.6)

On Groys' logic, though, such culture wars cannot be the existential threat they are often portrayed as. Rather, they give life to the archive; they allow it to be reaffirmed. And due to the infinite circulation of new media, they are reaffirmed in shifting and changing ways. This creates a point of irony, because while the preservation of culture is ultimately about the defence of certain values, this is not a fixed or passively maintained set of morals as Hunter suggests, but rather an interpretative act that takes place every time the borders of the cultural archive are tested. Even profane spaces are not themselves value-less; they simply present fleeting and unpreserved values which can challenge, provoke or mock the sacred. It is not so much that culture and value coincide, but that any creation of value depends upon the ability to remember, and to remember depends on preservation.

The memorialisation conflicts over statues of slavers or confederate generals bring into focus how the cultural archives encompass all of those spaces in which the unchanged or the memorialised are stored; the availability of which is always changing. Museums close, digital capacity grows (as Jaffe noted), and, in this way, what is kept and what is not becomes a contested space, as just about anything profane (outside the archive) can be potentially counted as sacred (inside the archive). The stability of the distinction between what is sacred and what is profane is therefore only guaranteed by repetition, or at least the repetition of novelties and differences. Groys understands the profane realm to reflect the values of the cultural archives – it is 'constantly renewed, because it is constantly filled with the refuse and waste products of valorised culture' (2014: 128). And it is precisely in this refuse and waste which we find clichés: terms which were once perhaps meaningful but no longer sit in

a clear place of reference to one particular thing.

It's okay to be angry

If the culture-value relationship is far more dynamic than Hunter's narrative suggests, it is effectively stabilised by the dominance of war as a trope for cultural disagreement; a trope which informs and is informed by the procedural polarity discussed earlier, and which insists that the nuances of value and re-value are settled into two opposing sides. However, the issue of anger, violence and war is also subject to a mediating aspect, just as values are mediated by the economy of the archival preservation.

For Hunter, war is the opposite of democracy, because democracy is about consensus and compromise (its fundamental consensus being the agreement to not war). We know, though, that there is a sizeable role for anger, frustration and even mild irritation in public debate before we get to actually taking up arms; just as there is a difference again between the calculated hatred of shitposting or online threats, and the annoyance from trying to show someone their viewpoint is ill-informed. I am not so interested in re-categorising acts of anger (in the sense of 'one man's terrorist is another's...'), but rather in the mediatory aspect of what is so often portrayed as instinctual or barbaric.

In his book *Rage and Time,* Peter Sloterdijk argues that the language of war and the threat of violence misrepresents the transformative energy of anger. Rage is too often treated as instrumental (or damaging, or pathological, etc.) to its users, which is to skip over (or purposefully defer from) the phenomenon of anger and violence itself, and in doing so, domesticate anger as a misguided way of achieving one's objectives. For Sloterdijk, rage must instead be understood as a form of capital: something which is *spent* (in acts of vengeful violence) or *invested*. It is the treatment of such investment that brings attention to the complex ways in which notions of

'legitimate' rage are assembled. As such, what at first appears 'like the highest level of running amok in reality consisted of bureaucracy, party organisation, routine, and the effects of organisational reflection' (2010, p.26).

Organisational reflection is built around an archival sensibility, of course: its authority is, like the *archons* of Ancient Greece, embedded in the preservation of a hidden system of regulations, strategies and documents. In this way, the history of Western culture is one of suppressing thymotic instincts: not denying them, per se, but rather storing or investing them in order to gain 'interest' until they are finally acted upon. For the most part such individual rage 'projects' – the dissenter in the committee, the angry mob, or even the riot against enforced face masks – fail. But if individual, local rage projects are collected, centralised and stored, under the guidance of a 'single administration' – a Church, a party, an ideology – then they can form 'rage banks' (Sloterdijk, 2010, p.62). Thus, a future world is promised through the eventual release of rage in collective form – revolution – and the destruction it brings. This, Sloterdijk argues, is a basic structure of meaning in life: 'rage projects' gear life towards the fulfilment of vengeance at a point in the future. Rage becomes a basic condition of history.

Ironically, however, this rationalisation of rage is also a form of domestication, meaning that while investment increases the potential effectiveness of rage, it also leads to a practical deferral from the thymotic impulse. True to any monopolised market, when a rage bank is formed the more local or individual rage projects are condemned for their wasted expenditures without significant returns. Sloterdijk argues that in the early twenty-first century, despite the fall of the central banks of rage (Christianity and Communism), there is no 'real decrease of available quantities of rage among the excluded, ambitious, unsuccessful, and vengeful'. (2010, p.190) However, today's rage cannot be treated in the same way. The dominance of neoliberal

capitalism sees 'an era without rage collection points of a global perspective'. (2010, p.183) Whereas the workers' movements of the nineteenth and early twentieth centuries could invest in narratives which linked them across borders and localities, this world lacks any such convincing story. Rage remains embedded within a wider system of market investiture: a world where, as Mark Fisher describes, 'capitalism seamlessly occupies the horizons of the thinkable' (2009, p.8). The political formations and ideologies available can appear as 'dysfunctional relics' in the current neoliberal context: 'condemned to struggle with ugly speeches against images of beautiful people and tables of solid numbers' (Sloterdijk, 2010, p.202). The protest movements and 'culture warriors' of the new millennium may look for alternatives from the totalitarian systems of the past, but are too often based upon the same principle of rage investment.

Instead, the anger that Hunter fears in the culture wars is less a gathering around core values and defined communal sensibilities, and rather a shifting between an array of different archives and collections, an almost constant re-valuation of value given the fluctuating space in which such collections might be stored or situated. Hence, for Sloterdijk, the result of the destruction of the rage banks is either a return to 'subcultural narratives' such as ethnicity, or, we might perhaps add, the notion of the 'sovereign citizen' rejuvenated by coronavirus restrictions. Failing this: 'the only available option is to escape to their own mirror image, which is provided by mass media as soon as scenes of violence attract public interest...However, it is in precisely such episodes that the medium wins over content' (Sloterdijk, 2010, p.205). In other words, rage cannot be transformed into pride or hope, when the symbolism of protest is consumed as an image-icon: activities of resistance, in many cases themselves re-enactments of earlier image-icons of resistance, are uploaded to networked media and circulated through repetitive replaying, tagging and sharing.

Of course, Sloterdijk's account of rage investment came before the collapse of the banking sector in 2009; but this perhaps reinforces the main idea I take from this, which is that anger is not simply an individual psychological or physiological response, a form of frustration or violent stupidity, but is embedded within a process of mediation. Rage is a system of investments that are central to the progression of history. In this way, Sloterdijk's rage bank is a reversal of the curating task of culture. One requires deferral to the future, the other requires deferral to the preservation of the present via the organisation of the past. If both are fundamental to the development of understanding – the creation of new knowledge, comprise, education, and so on – then it seems difficult to believe that the hard work of better dialogue can sit outside of this mediation.

The problem with dialogue

When it comes to proposing a solution to the culture wars, Hunter and Stanton agree that the answers aren't easy. However, Hunter is not ashamed to lean back on the principles of European Enlightenment as a starting point.

> I'm going to sound really old-fashioned here, but I think that this work takes a long time and it's hard. I think you talk through the conflicts. Don't ignore them; don't pretend that they don't exist. And whatever you do, don't just simply impose your view on anyone else. You have to talk them through. It's the long, hard work of education. (Stanton 2021)

Indeed, sounding old-fashioned is noticeable throughout Hunter's analysis. Even in the less formal confines of a magazine interview, he frequently talks in the early modern language of 'passions' and 'sins'; he describes democracy in terms of the Hobbesian idea of an 'agreement not to kill each other'; he stresses the importance of narratives for making

sense of one's culture, but these narratives are also emphatically traditional, with a tidy linearity leading to a wary, but hopeful, conclusion. As such, his descriptions of the descent of meaning to non-meaning, democracy to violence, and hyper-attention to shallowness are corrected by reversal; a reversal which reinstates the original dream of modernity.

Given that this is likely to fail (Hunter acknowledges he isn't optimistic) we are effectively left with the repetitive echoes of that dream, which is most clear in the form of the impromptu self-help manual – work hard, reap the rewards – which Hunter concludes with. Indeed, such a call for renewed and humbler dialogue resonates with many similar recommendations on what to do when cultural disconnection is rooted, at least in part, in ignorance. Consider Andre Spicer's advice on the topic:

> constantly dismissing the other side as stupid can be dangerous. It's unlikely to foster dialogue, and will instead drive political factions ever further apart. Politics will become a grudge match between factions who consider their opponents idiots and therefore refuse to listen to them. Whenever this sort of vicious partisanship kicks in, voters become more likely to follow their own politics when making a decision – no matter what the evidence says.
> (Spicer, 2016)

Like Lee McIntyre's work, both Hunter and Spicer's rejection of the dualism between the informed, considerate and good, and the stupid, aggressive and bad is a valuable ethos to follow. The sentiments cannot escape irony, though. After all, even if one agrees that politics is about finding agreement and compromise within the public sphere, many instances of the cultural battles *begin* from the very effort to talk more, to educate, to make visible tensions within the understanding and recognition of those occupying shared social and political spaces. The idea that

voters may 'follow their own politics' seems an odd warning to make (how else does one participate in politics?). It is clarified by the suggestion of factions and tribalism; simply following your 'in-group' line is a sign of barbarity unbefitting a modern democracy. However, barbarity is also indicative of stupidity; the very same labelling that the passage began by warning us against.

Spicer's view could thus be seen as a kind of individualistic re-enactment of what Jacques Ranciere critiques in structural social criticism. On the one hand, Ranciere argues, such social criticism links emancipation to intellectual discovery; on the other hand, it is resigned to the perpetuity of a system which blocks it. Certain groups (class, race, age, the 'left behind' and so on) are said to be excluded from knowledge because they don't know the true reasons that they can't access that knowledge; but their ignorance is a product of the systems of knowledge that don't let them in. If only they knew, they would know! The critics can only sigh and move on, slightly more exasperated.

A further example: one of the most important books on ignorance, at least in analytic philosophy, has been Miranda Fricker's work on epistemic injustice. Fricker is less interested in ignorance *per se* and more the exclusion of certain groups being deemed to be 'knowers', arguing that this exclusion is both epistemological and hermeneutic in nature. As such, the work is an important step towards re-imagining the focus of traditional studies on knowledge. However, it also demonstrates, inadvertently, the problem with appeals to dialogue such as Hunter's. For Fricker, addressing epistemic injustice requires awareness of different levels of interpretation, or 'intellectual gears', with which we respond to claims to knowledge. A level of 'spontaneous, unreflective' response can often bear a number of unfair prejudices by a listener against a speaker. However, Fricker suggests that if one suspects prejudice to their 'credibility judgement' – through a sense of cognitive dissonance, emotional

response and so on – then they should shift their intellectual gear into 'active critical reflection in order to identify how far the suspected prejudice has influenced her judgement' (2007, p.91).

It is interesting, though, that all of the examples that Fricker uses involve dealing with a first-hand dialogue between a speaker and a listener; but each dialogue is a reported narrative, a retelling (for the purpose of explicating her argument), with her recurrent example being Tom Robinson from *To Kill a Mockingbird*. These stand as ideal cases, carefully constructed narrative devices to expose the clear ignorance of one group or the exclusion of another. This seems to me to keep the analysis contained within a certain mode of knowing: canonical literature, well-established within school curricula. This is not to say that it can't be a useful example; but the full context of the example, and its effect on its persuasive power, is not explored. As a result, we are left with a solution that focuses on the self-reflection of the individual, presented through a diverse web of social, pedagogical and referential relationships. It is, in this sense, an example of Theodore George's suggestion that, 'in many quarters, whether in the academy, the media, or even the arts, the concern to tarry on the political, to attempt to make things visible in a new way, is increasingly squelched in the name of frames of debate that already have accepted trappings and established channels of dissemination' (George, 2020, p. 142). It is just that the frame of debate is not so much exclusionary language or accusations of a lack of epistemic credibility (or more bluntly: stupidity), but rather the ways in which mediation is imagined: the expectations of what a dialogue is, for example.

Hermeneutic complicity

While perhaps not as complex as Jaffe's account of spoilers, there is a similar interplay here between how expectations

133

are tacitly accepted and usurped. As Ranciere noted, such an interplay is often overlooked simply because it is unnecessary to examine them: the explanation of the limits of intellectual emancipation make perfect sense, just as the suggestion of engaging in dialogue, rather than throwing around insults of stupidity, seems an utterly reasonable approach. This, I think, takes us directly to the issue of interpretation at work in Hunter's treatment. What emerges from such approaches is a form of hermeneutic complicity: that is, an act of interpretation that embeds or obscures certain senselessness *in order that* sense be made, or changes be recommended, or action be taken. To put it in hermeneutic terms: it is to go through the motions of 'fusing' one's horizons, while leaving some aspects of that fusing unsaid, and in doing so resulting in a form of dissonance between wanting to understand, and already understanding well enough, possibly better.

Hermeneutic complicity is a mutated form of understanding, closely aligned to the communal nature of interpretation. In Gadamer's hermeneutics, for example, individual interpretations are necessarily rooted in a communal language and tradition: there can be no understanding without this (hence the connection between community and communication), which is why Gadamer describes the emphasis on subjectivity within interpretation as 'a distorting mirror'. In this way, there must always be a participation or collaboration with these existing sense-making forms because the, 'self-awareness of the individual is only a flickering in the closed circuits of historical life. That is why the prejudices of the individual, far more than his judgements, constitute the historical reality of his being' (2004, p.278). Furthermore, interpretation is always necessarily incomplete; just as the past and future are organised by shifting investments in value. It is entirely possible to understand, while remaining aware that this understanding won't last forever.

At the same time, Gadamer's own political conservatism

means the qualities of these prejudices are often assumed a certain coherence and territoriality. The most notable of this for Gadamer is his use of an ideal model of dialogue between two or more speakers, mediated by language, to ground his account of 'understanding'. This is where the complicit aspect of interpretation arises: precisely when a particular mode of sense-making, despite its commitment to an open-ended account of truth, overrules the more ambiguous or subversive aspects of understanding. For example, Gadamer sees irony as a confirmation of the dialogical nature of understanding. 'Every conversation,' he claims, 'presupposes a common language, or, creates a common language.' When irony subverts language, this can only happen based on the expectation of understanding beyond irony: there can be no irony if interlocutors haven't identified a shared topic of conversation, because otherwise there isn't anything to ironise. Persuasive as this may be, it is also where the commitment to dialogical understanding becomes a form of interpretative complicity with ideal models of conversation: models which, as we have seen, are rooted in a range of intellectual, historical and cultural commitments that may unwittingly close the open access that dialogue promises. As I suggested in Chapter Four, it is entirely possible to retain the idea of understanding as a fusion of horizons, while also noting that a two-way conversation does not reflect the ways in which such fusions occur in an age of interconnected digital and print platforms; but this would involve irony being a condition of understanding, and not the other way around.

As before, it is important not to see access here as simply a threshold or gateway, which might suggest that the way to address this kind of complicity is to reduce all conversations to the lowest common denominator; cancelling any examples which may not be understood, and ending up with something akin to the patronising 'plain language summary' that research grants require. This would suggest that the way forward is to find

some kind of shared language or approved model of dialogue where differences can be resolved, and there would be no need to deploy 'the stupid'. In fact, this is the worst thing we could do. As Ranciere argues, in between the communicator's ideas (in Ranciere's case, an artist) and the receiver (the audience), there exists a 'third thing' that mediates the separation between the two: be it a book, a message board, a Twitter platform. It 'is owned by no one, [and] whose meaning is owned by no one' but nevertheless 'subsists between them, excluding any uniform transmission, any identity of cause and effect' (Ranciere, 2009, p.15). The temptation is to refuse this mediation by imagining a 'communitarian essence' to a production – be this a theatrical performance, in Ranciere's case, or a genuine and hard-earned dialogue between the stupid and the non-stupid, a scene of 'really listening' and paying attention. However, for Ranciere, the aim should not be to enforce a communal body on to an audience. This is precisely where interpretative complicity becomes something more than a passing tactic for making sense of complexity (which is all but unavoidable), and instead becomes something that perpetuates those structures that have brought us to the malaise of the stupid in the first place. Rather, the empowerment of the audience is precisely the contingency of these mediating 'things': it is the 'power of associating and dissociating' (Ranciere, 2009, p.17), which is not limited to staged events in the theatre but 'is our normal situation'. In identifying this empowerment, he argues, 'we have to recognise the knowledge at work in the ignoramus'.

Recognising this 'knowledge at work' is a step forward, not to privileging the idiot (as Han sometimes suggests) or downplaying the intellectual, but to taking account of the banal contingencies, the ironies, the spoilers, the chatter and the habitual repetitions that constitute any interpretation of public debates so focused on what it means to be intelligent. If this is all a bit abstract, John Keane describes something very similar

in his argument that post-truth cannot simply be combatted by recourse to a singular idea of truth. It is this, he suggests, that is in fact the real threat to democracy:

> Democracy is a living reminder that truths are never self-evident, and that what counts as truth is a matter of interpretation. Recognising that in political life "truth has a despotic character", democracy stands for a world beyond truth and post-truth…[D]emocracy supposes that no man or woman is good enough to claim they know the truth and to rule permanently over their fellows and the earthly habitats in which they dwell. (Keane 2018)

Do you remember when Marx wrote in his Eleventh Thesis on Feuerbach that, up until now, the philosophers have only interpreted the world, but the point is to change it? Yeah, it wasn't that. As a commonplace in public debate, 'the stupid' is empowered by interpretative relationships that are mediated by archival sensibilities and investment systems. If we are to address the problem of the stupid, it is these relationships that need attending to. Marx is reversed: the point is not to change the world, but first to interpret it.

References

Anker, E. and Felski, R. (2017). Introduction. In Anker, E. and Felski R. (eds.), *Critique and Postcritique.* Duke University Press, 1-29.

Arendt, H. and Scholem, G. (2017). *The Correspondence of Hannah Arendt and Gershom Scholem,* ed. Knott, M.. trans. David, A. University of Chicago Press.

Arfini, S. (2019). *Ignorant Cognition: A Philosophical Investigation of the Cognitive Features of Not-Knowing.* Springer International.

Ashton, J. (2020). *Blinded by Corona.* Gibson Square.

Bacon, M. (2005). A Defence of Liberal Ironism. *Res Publica,* 11(4), 403–423. https://doi.org/10.1007/s11158-005-5761-0

Bailey, E. (2019). *The Cure for Stupidity.* Peacock Proud Press.

Barthes, R. (1973). *Mythologies* Trans. Lavers, A. Paladin.

Baudrillard, J. (1977 [2007]). *Forget Foucault.* trans. N. Dufresne. semiotext(e).

Beckett, A. (2021, October 15). The Conservatives are in more danger than they think. *The Guardian.* https://www. theguardian.com/commentisfree/2021/oct/15/conservatives-danger-levelling-up-complacent

Behr, R. (2017, February 22). Politicians love the 'left-behind' cliche. It masks their own failure. *The Guardian.* https://www. theguardian.com/commentisfree/2017/feb/22/politicians-love-left-behind-cliche-brexit

Berardi, F. (2009a). *The Soul at Work.* Semiotext(e).

-------- (2009b). *Precarious Rhapsody: Semiocapitalism and the Pathologies of the Post-Alpha Generation.* Trans. A. Bove, E. Empson, M. Goddard, G. Mecchia, A. Schintu, and S. Wright. Minor Compositions.

-------- (2011). *After the Future.* Trans. A. Bove, M. Cooper, E. Empson, G. Mecchia and T. Terranova. AK Press.

-------- (2012). *The Uprising: On Poetry and Finance.* Semiotext(e).

-------- (2015). *Heroes: Mass Murder and Suicide*. Verso.

-------- (2021, January 13). What Abyss Are We Talking About? e-flux https://www.e-flux.com/announcements/371876/bifo-on-the-us-capitol-riots/

Bernstein, Richard J. (2016). *Ironic Life*. Polity.

Bishop, K. (2009). Dead Man Still Walking: Explaining the Zombie Renaissance. *Journal of Popular Film and Television*, *37*(1), 16-25.

Boland, T. (2019). *The Spectacle of Critique*. Routledge.

Breakey, H. (2020, July 10). Is cancel culture silencing open debate? There are risks to shutting down opinions we disagree with. *The Conversation* https://theconversation.com/is-cancel-culture-silencing-open-debate-there-are-risks-to-shutting-down-opinions-we-disagree-with-142377

Brennan, J (2016). *Against Democracy.* Princeton University Press.

Bridle, J. (2018). *New Dark Age: Technology and the End of the Future*. Verso.

Brooker, C. (2021, February 11). Charlie Brooker in conversation with Adam Curtis. *Vice.* https://www.vice.com/en/article/4ad8db/adam-curtis-charlie-brooker-cant-get-you-out-of-my-head

Calcutt, A. (2016, November 18). The surprising origins of 'post-truth' – and how it was spawned by the liberal left. *The Conversation.* https://theconversation.com/the-surprising-origins-of-post-truth-and-how-it-was-spawned-by-the-liberal-left-68929

Carley, S., Horner, D., Body, R. and Mackway-Jones, K. (2020). Evidence-based medicine and COVID-19: what to believe and when to change. *Emergency Medicine Journal*, *37*, 572–575. doi:10.1136/emermed-2020-210098

Curtis, W. (2015). *Defending Rorty: Pragmatism and Liberal Virtue*. Cambridge University Press.

D'Ancona, M. (2017). *Post-Truth: The New War on Truth and How*

to Fight Back. Ebury Press.

Datacide (ND). Plague of the Zombies. *Datacide: Magazine for Noise and Politics.* https://datacide-magazine.com/plague-of-the-zombies/

Deleuze, G. (1962/2006). *Nietzsche and Philosophy.* Trans. Tomlinson, H. Continuum.

De Man, P. (1996). *Aesthetic Ideology.* University of Minnesota Press.

Derrida, J. (2009). *The Beast and the Sovereign, Volume 1,* trans. Bennington, G. University of Chicago Press.

Dickerman, L., Foster, H., Joselit, D. & Lambert-Beatty, C. (2018). A Questionnaire on Monuments. October, 135, 3-177.

Eilperin, J. (2016, December 11). Trump says 'nobody really knows' if climate change is real despite broad scientific consensus. *The Chicago Tribune* http://www.chicagotribune.com/news/nationworld/politics/ct-trump-climate-change-20161211-story.html

Felski, R. (2015). *The Limits of Critique.* University of Chicago Press.

Fernandez, H. (2017). Idiocy of the Masses. *Contours* 8, http://www.sfu.ca/humanities-institute/contours/issue8/psycho-trump/3.html

Fischer, S. (2020, December 22). 'Unreliable' news sources got more traction in 2020. *Axios.* https://www.axios.com/unreliable-news-sources-social-media-engagement-297bf046-c1b0-4e69-9875-05443b1dca73.html

Fisher, M. (2009). *Capitalist Realism.* Zer0 Books.

-------- (2013, November 24). Escaping the Vampire Castle. *OpenDemocracy.* https://www.opendemocracy.net/en/opendemocracyuk/exiting-vampire-castle/

-------- (2021). *Postcapitalist Desire: The Final Lectures.* Ed. Colquhoun, M. Repeater Books.

Forti, S. (2015). *New Demons: Rethinking Power and Evil Today.* Stanford University Press.

Foucault, M. (1983/2001). *Fearless Speech*. Ed. Pearson, J. Semiotext(e).

Gadamer, H-G. (2004). *Truth and Method*. Trans. Weinsheimer, J. and Marshall, D. Continuum.

-------- (1996). *The Enigma of Health*. Trans. Gaiger, J. and Walker, N. Polity Press.

George, T. (2020). *The Responsibility to Understand: Hermeneutical Contours of Ethical Life*. Edinburgh University Press.

Giroux, H. (2010). Zombie Politics and Other Late Modern Monstrosities in the Age of Disposability. *Policy Futures in Education*, 8(1), 1-6.

-------- (2014). *Neoliberalism's War on Higher Education*. Haymarket.

Goodfellow, M. (2018, July 29). I'm trying to write about Brexit satirically – but it's actually true. *The Independent*. https://www.independent.co.uk/voices/brexit-lies-article-50-general-election-nigel-farage-humour-satire-not-funny-a8468691.html

Goldberg, J. (2011). *The Tyranny of Clichés: How Liberals Cheat in the War of Ideas*. Sentinel.

Grabar, H. and Mathis-Lilley, B. (2020 December 23). The Dumbest Moments of the Trump Presidency. *Slate*. https://slate.com/news-and-politics/2020/12/donald-trump-stupid-moments-dumb-comments.html

Graeber, D. (2015). *The Utopia of Rules: On Technology, Stupidity and the Secret Joys of Bureaucracy*. Melville House.

Greenaway, C., Hargreaves, S., Barkati, S., Coyle, C., Gobbi, F., Veizis, A., and Douglas, P. (2020). COVID-19: Exposing and addressing health disparities among ethnic minorities and migrants. *Journal of Travel Medicine*, 27(7), 1-3. https://doi.org/10.1093/jtm/taaa113

Greenberg, C. (1961) *Art and Culture: Critical Essays*. Beacon Press.

Greteman, B. (2014, June 13) It's the End of the Humanities as We Know It and I feel fine. *The New Republic*. https://

newrepublic.com/article/118139/crisis-humanities-has-long-history

Grimwood, T. (2008). The Problems of Irony: Philosophical Reflections on Method, Discourse and Interpretation. *Journal for Cultural Research*, 12(4), 349-363. https://doi.org/10.1080/14797580802579788

-------- (2012). *Irony, Misogyny and Interpretation*. Cambridge Scholars Publishing

-------- (2021). *The Shock of the Same: An Anti-Philosophy of Clichés*. Rowman & Littlefield International.

Groskop, V. (2016, August 4). Britain Needs a Large Dose of Proper Political Satire. *The Spectator* https://blogs.spectator.co.uk/2016/08/brexit-britain-needs-large-dose-proper-political-satire/

Groys, B. (2010). *Going Public*. Sternberg Press.

-------- (2012). *Under Suspicion*. Columbia University Press.

Haack, S. (1995). Vulgar Pragmatism: An Unedifying Prospect. In Saatkemp, H. (ed.) *Rorty and Pragmatism: The Philosopher Responds to His Critics* (pp.126-147). Vanderbilt University Press.

-------- (2019). Post 'Post-Truth': Are We There Yet? *Theoria, 85*, 258-275. https://doi.org/10.1111/theo.12198

Han, B-C. (2015). *The Burnout Society*. Stanford University Press.

-------- (2017). *Psychopolitics: Neoliberalism and New Technologies of Power*. Verso.

Hanchey, J. N. (2018). Toward a relational politics of representation. *Review of Communication*, 18(4), 265-283.

Harding, S. (2006). Two Influential Theories of Ignorance and Philosophy's Interests in Ignoring Them. *Hypatia*, 21 (3), pp.20-36.

Hawkes, N. (2017). A brief history of post-truth in medicine. *BMJ, 358*, 4193. https://pubmed.ncbi.nlm.nih.gov/28893829/

Heinrich, S. (2020) Medical science faces the post-truth era: a plea for the grassroot values of science. *Current Opinion in*

Anaesthesiology, 33(2), pp.198-202. https://pubmed.ncbi.nlm. nih.gov/31972566/

Hopf, H., Krief, A., Mehta, G., Matlin, S.A. (2019). Fake science and the knowledge crisis: ignorance can be fatal. *Royal Society Open Science, 6*(5), 1-7. https://doi.org/10.1098/rsos.190161

Jolly, B. (2020, February 1). Brexiteers try to set EU flag on fire – but fail due to European fireproofing rule. *The Mirror.* https://www.mirror.co.uk/news/politics/brexiteers-try-set-eu-flag-21407117

Karloff, B. (ND). Resisting Zombie Culture. http://www. uncarved.org/turb/articles/karloff.html

Keane, J. (2018, March 23). Post-truth politics and why the antidote isn't simply 'fact-checking' and truth. *The Conversation.* https://theconversation.com/post-truth-politics-and-why-the-antidote-isnt-simply-fact-checking-and-truth-87364

Keen, A. (2011). *The Cult of the Amateur.* 2nd ed. Nicholas Brealey Publishing.

Kellner, D. (2004). 9/11, Spectacles of Terror, and Media Manipulation: A Critique of Jihadist and Bush Media Politics. Critical Discourse Studies, 1(1),41-64.

Kerr, A., Kücklich, J., and Brereton, P. (2006). New Media – New Pleasures? *International Journal of Cultural Studies.* 9(1), 63-82. https://doi.org/10.1177/1367877906061165

Klossowski, P. (2007). *Such a Deathly Desire.* SUNY Press.

Kruger, J. and Dunning, D. (1999). Unskilled and Unaware of It: How Difficulties in Recognizing One's Own Incompetence Lead to Inflated Self-Assessments. *Journal of Personality and Social Psychology,* 77(6), 1121–1134. https://doi. org/10.1037/0022-3514.77.6.1121

Krugman, P. (2020). *Arguing with Zombies: Economics, Politics, and the Fight for a Better Future.* W.W. Norton.

Laclau, E. (2005). *On Populist Reason.* Verso.

Landemore, H. (2017). *Democratic Reason: Politics, Collective*

Intelligence, and the Rule of the Many. Princeton University Press.

Lanz, H. (1936). The Metaphysics of Gossip. *International Journal of Ethics, 46*(4), 492-499.

Latour, B. (2004). Why Has Critique Run out of Steam? From Matters of Fact to Matters of Concern. *Critical Inquiry* 30(2), 225–48.

-------- (2008). A Cautious Prometheus? A Few Steps toward a Philosophy of Design (with Special Attention to Peter Sloterdijk). In Hackney, F., Glynne, J., and Minton, V. (eds.) *Networks of Design. Proceedings of the 2008 Annual International Conference of the Design History Society (UK).* University College Falmouth.

-------- (2013). *An Inquiry into Modes of Existence.* Harvard University Press.

Lear, Jonathan (2011). *A Case for Irony.* Harvard University Press.

Le Bon, G. (1895/2006). *The Crowd: A Study of the Popular Mind.* Cosimo Classics.

McGoey, L. (2019). *Unknowers: How Strategic Ignorance Rules the World.* Zed Books.

McIntyre, L. (2018). *Post-Truth.* MIT Press.

-------- (2021). *How to Talk to a Science Denier: Conversations with Flat Earthers, Climate Deniers, and Others Who Defy Reason.* MIT Press.

Malone, T. (2018, October 31). The Zombies of Karl Marx: Horror in Capitalism's Wake. Literary Hub. https://lithub.com/the-zombies-of-karl-marx-horror-in-capitalisms-wake/

Marazzi, C. (1994/2011). *Capital and Affects: the Politics of the Language Economy.* Semiotext(e).

Mason, P. (2015). *PostCapitalism: A Guide to Our Future.* Allen Lane.

Mills, C. (2007). White Ignorance. In Sullivan, S. and Tuana, N. (eds), *Race and Epistemologies of Ignorance.* University of New York Press.

Mills, J. (2018). *Left Behind: Why voters deserted social democracy –
and how to win them back.* CIVITAS. https://www.civitas.org.
uk/content/files/leftbehind.pdf

Mitchell, G. (2005). Libertarian Paternalism is an Oxymoron.
Northwestern University Law Review, 99(3), 1245-1276.

Muecke, D. C. (1969). *The Compass of Irony.* Methuen.

Nafilyan, V., Islam, N., Ayoubkhani, D., Gilles, C., Katikireddi,
S., Mathur, R., Summerfield, A., Tingay, K., Asaria, M.,
John, A., Goldblatt, P., Banerjee, A., Glickman, M. and
Khunti, K. (2021). Ethnicity, household composition and
COVID-19 mortality: a national linked data study. *Journal
of the Royal Society of Medicine,* March 2021, 1-30. https://doi.
org/10.1177/0141076821999973

Norberg, J. (2018). The Tragedy of the Commonplace. *Fast
Capitalism* 15(1), 71-80.

Oxford English Dictionary, (ND). 'Post-truth'. https://
en.oxforddictionaries.com/definition/post-truth

Pariser, E. (2012). *The Filter Bubble: What The Internet Is Hiding
From You.* Penguin.

Paul, K. and Haddad, C. (2019). Beyond evidence versus
truthiness: toward a symmetrical approach to knowledge
and ignorance in policy studies. *Policy Sciences,* 52(2), 299–
314. https://doi.org/10.1007/s11077-019-09352-4

Platts, T. (2013). Locating Zombies in the Sociology of
Popular Culture. *Sociology Compass,* 7, 547-560. https://doi.
org/10.1111/soc4.12053

Proctor, R. (2008). Agnotology: A Missing Term. In Proctor,
R. and Schiebinger, L. (eds) *Agnotology: The Making and
Unmaking of Ignorance.* Stanford University Press, 1-33.

Ranciere, J. (2009). *The Emancipated Spectator.* Trans. G. Elliot.
Verso.

Rehak, B. (2007) Of eye candy and id: the terrors and pleasures
of Doom 3. In Atkins, B. and Krzywinska, T. (eds.) *Videogame,
Player, Text.* Manchester University Press, 139-157.

Roberts, D. (2017, May 19). Donald Trump and the rise of tribal epistemology. *Vox*. https://www.vox.com/policy-and-politics/2017/3/22/14762030/donald-trump-tribal-epistemology

Rogin, M. (1988). *Ronald Reagan: The Movie and Other Episodes in Political Demonology*. University of California Press.

Roose, K. (2021, September 3). What Is QAnon, the Viral Pro-Trump Conspiracy Theory? *New York Times*. https://www.nytimes.com/article/what-is-qanon.html

Rorty, Richard (1989). *Contingency, Irony and Solidarity*. Cambridge University Press.

-------- (1991). *Objectivity, Relativism and Truth: Philosophical Papers Vol. 1*. Cambridge University Press.

-------- (2000). Universality and Truth. In Brandom, R. (ed.) *Rorty and his Critics* (pp.1-30). Blackwell.

Rosenberg, S. (2020). Democracy Devouring Itself: The Rise of the Incompetent Citizen and the Appeal of Right-Wing Populism. In Hur, D. and Sabucedo, J. (eds.) *Psychology of Political and Everyday Extremisms*. Editora Vozes.

Salmon, C. (2010). *Storytelling: Bewitching the Modern Mind*. Verso.

Siegel, E. (2020, August 30). You must not do your own research when it comes to science. *Forbes*. https://www.forbes.com/sites/startswithabang/2020/07/30/you-must-not-do-your-own-research-when-it-comes-to-science/

Sirota, D. (2009, October 12). Zombie Zeitgeist: Why Undead Corpses Are Dominating at the Box Office. *Mother Jones* https://www.motherjones.com/media/2009/10/zombie-zeitgeist-why-undead-corpses-are-dominating-box-office/

Sloterdijk, P. (2010). *Rage and Time*. Trans. M. Wenning. Columbia University Press.

Spence, S. (2007). *Figuratively Speaking: Rhetoric and Culture from Quintilian to the Twin Towers*. Gerald Duckworth & Co Ltd.

Spicer, A. (2016, August 15). Calling your political opponents

'stupid' is a stupid thing to do. *The Conversation.* https://theconversation.com/calling-your-political-opponents-stupid-is-a-stupid-thing-to-do-62926

Standing, G. (2018, January 21). The Precariat are not the Left Behind. *World Economic Forum.* https://www.weforum.org/agenda/2018/01/who-exactly-are-the-left-behind-2018/

Stanley, T. (2015, April 8). In this joke of an election, who needs satire? *The Telegraph.* https://www.telegraph.co.uk/news/general-election-2015/politics-blog/11521511/In-this-joke-of-an-election-who-needs-satire.html

Stanton, Z. (2021, May 20). How the 'Culture War' Could Break Democracy. *Politico.* https://www.politico.com/news/magazine/2021/05/20/culture-war-politics-2021-democracy-analysis-489900

Stelter, B. (2011, May 1) How the Bin Laden Announcement Leaked Out. *New York Times.*

Stonebridge, L. (2018, December 17). Brexit is worse than stupid—it's thoughtless. https://www.prospectmagazine.co.uk/other/brexit-is-worse-than-stupid-its-thoughtless

Tabori, P. (1993. *The Natural History of Stupidity.* Barnes and Noble.

Taleb, N. (2016, September 16). The Intellectual Yet Idiot. *Medium.* https://medium.com/incerto/the-intellectual-yet-idiot-13211e2d0577

Terranova, T. (2004). *Network Culture: Politics for the Information Age.* Pluto Press.

Tillich, P. (1936). *The Interpretation of History.* Charles Scribner's Sons.

Townley, C. (2020). Toward a Revaluation of Ignorance. *Hypatia,* 21(3), 37-55.

Tuteur, A. (2016, September 8). Dunning Kruger nation and the disparagement of expertise. *The Skeptical OB.* https://www.skepticalob.com/2016/09/dunning-kruger-nation-and-the-disparagement-of-expertise.html

Van Dyke, M., Mendoza, M., Li, W., Parker, E., Belay, B., Davis, E., Quint, J., Penman-Aguilar, A., Clarke, K. (2021). Racial and Ethnic Disparities in COVID-19 Incidence by Age, Sex, and Period Among Persons Aged <25 Years — 16 US Jurisdictions, January 1–December 31, 2020. *Morbidity and Mortality Weekly Report,* 70(11), 382–388. http://dx.doi.org/10.15585/mmwr. mm7011e1

Vattimo, G. and Zabala, S. (2011). *Hermeneutic Communism.* Columbia University Press.

Vogelmann, F. (2018). The Problem of Post-Truth: Rethinking the Relationship between Truth and Politics. *Behemoth: A Journal on Civilisation, 11*(2), 18-37. https://doi.org/10.6094/ behemoth.2018.11.2.986

Waisanen, D. and Becker, A. (2015). The Problem with Bring Joe Biden: Political Comedy and Circulating Personae. *Critical Studies in Media Communication,* 1-16.

Waisanen, D. (2019). The Political Economy of Late-Night Comedy. In Webber, J. (ed.), *The Joke is On Us: Political Comedy in (Late) Neoliberal Times* (pp.159-175). Rowman & Littlefield.

Wampole, C. (2016, December 9). How to Live Without Irony (For Real This Time). *The New York Times.* https://www.nytimes. com/2016/12/19/opinion/how-to-live-without-irony-for-real-this-time-.html?_r=0

Ward, S. C. (2012). *Neoliberalism and the global restructuring of knowledge and education.* Routledge.

Waterson, J. (2019, December 5). Uncovered: reality of how smartphones turned election news into chaos. *The Guardian.* Available at https://www.theguardian.com/politics/2019/ dec/05/uncovered-reality-of-how-smartphones-turned-election-news-into-chaos

Willett, C. (2008). *Irony in the Age of Empire: Comic Perspectives on Democracy and Freedom.* Indiana University Press.

Wolffe, R. (2020, September 10). Trump told a reporter his biggest secret: that he is a danger to the American

people. *The Guardian*. https://www.theguardian.com/
commentisfree/2020/sep/10/donald-trump-bob-woodward-
interviews

Zijderveld, A. (1979). *On Clichés: The Supersedure of Meaning by
Function in Modernity*. Law Book Co of Australasia.

Žižek, S. (2004). *Organs without Bodies: On Deleuze and
Consequences*. Routledge.

-------- (2020). *Pandemic! COVID-19 Shakes the World*. Polity Press.

CULTURE, SOCIETY & POLITICS

Contemporary culture has eliminated the concept and public figure of the intellectual. A cretinous anti-intellectualism presides, cheer-led by hacks in the pay of multinational corporations who reassure their bored readers that there is no need to rouse themselves from their stupor. Zer0 Books knows that another kind of discourse - intellectual without being academic, popular without being populist - is not only possible: it is already flourishing. Zer0 is convinced that in the unthinking, blandly consensual culture in which we live, critical and engaged theoretical reflection is more important than ever before.

If you have enjoyed this book, why not tell other readers by posting a review on your preferred book site.

You may also wish to
subscribe to our Zer0 Books YouTube Channel.

Bestsellers from Zer0 Books include:

Give Them An Argument
Logic for the Left
Ben Burgis
Many serious leftists have learned to distrust talk of logic. This
is a serious mistake.
Paperback: 978-1-78904-210-8 ebook: 978-1-78904-211-5

Poor but Sexy
Culture Clashes in Europe East and West
Agata Pyzik
How the East stayed East and the West stayed West.
Paperback: 978-1-78099-394-2 ebook: 978-1-78099-395-9

An Anthropology of Nothing in Particular
Martin Demant Frederiksen
A journey into the social lives of meaninglessness.
Paperback: 978-1-78535-699-5 ebook: 978-1-78535-700-8

In the Dust of This Planet
Horror of Philosophy vol. 1 Eugene Thacker
In the first of a series of three books on the Horror of
Philosophy, *In the Dust of This Planet* offers the genre of horror
as a way of thinking about the unthinkable.
Paperback: 978-1-84694-676-9 ebook: 978-1-78099-010-1

The End of Oulipo?
An Attempt to Exhaust a Movement
Lauren Elkin, Veronica Esposito
Paperback: 978-1-78099-655-4 ebook: 978-1-78099-656-1

Capitalist Realism
Is There No Alternative?
Mark Fisher
An analysis of the ways in which capitalism has presented
itself as the only realistic political-economic system.
Paperback: 978-1-84694-317-1 ebook: 978-1-78099-734-6

Rebel Rebel
Chris O'Leary
David Bowie: every single song. Everything you want to know,
everything you didn't know.
Paperback: 978-1-78099-244-0 ebook: 978-1-78099-713-1

Kill All Normies
Angela Nagle
Online culture wars from 4chan and Tumblr to Trump.
Paperback: 978-1-78535-543-1 ebook: 978-1-78535-544-8

Cartographies of the Absolute
Alberto Toscano, Jeff Kinkle
An aesthetics of the economy for the twenty-first century.
Paperback: 978-1-78099-275-4 ebook: 978-1-78279-973-3

Malign Velocities
Accelerationism and Capitalism
Benjamin Noys
Long listed for the Bread and Roses Prize 2015, *Malign
Velocities* argues against the need for speed, tracking
acceleration as the symptom of the ongoing crises of
capitalism.
Paperback: 978-1-78279-300-7 ebook: 978-1-78279-299-4

Meat Market
Female Flesh under Capitalism
Laurie Penny
A feminist dissection of women's bodies as the fleshy fulcrum
of capitalist cannibalism, whereby women are both consumers
and consumed.
Paperback: 978-1-84694-521-2 ebook: 978-1-84694-782-7

Babbling Corpse
Vaporwave and the Commodification of Ghosts
Grafton Tanner
Paperback: 978-1-78279-759-3 ebook: 978-1-78279-760-9

New Work New Culture
Work we want and a culture that strengthens us
Frithjof Bergmann
A serious alternative for mankind and the planet.
Paperback: 978-1-78904-064-7 ebook: 978-1-78904-065-4

Romeo and Juliet in Palestine
Teaching Under Occupation
Tom Sperlinger
Life in the West Bank, the nature of pedagogy and the role of a
university under occupation.
Paperback: 978-1-78279-637-4 ebook: 978-1-78279-636-7

Color, Facture, Art and Design
Iona Singh
This materialist definition of fine-art develops guidelines for
architecture, design, cultural-studies and ultimately social
change.
Paperback: 978-1-78099-629-5 ebook: 978-1-78099-630-1

Sweetening the Pill
or How We Got Hooked on Hormonal Birth Control
Holly Grigg-Spall
Has contraception liberated or oppressed women?
Sweetening the Pill breaks the silence on the dark side of
hormonal contraception.
Paperback: 978-1-78099-607-3 ebook: 978-1-78099-608-0

Why Are We The Good Guys?
Reclaiming Your Mind from the Delusions of Propaganda
David Cromwell
A provocative challenge to the standard ideology that Western
power is a benevolent force in the world.
Paperback: 978-1-78099-365-2 ebook: 978-1-78099-366-9

The Writing on the Wall
On the Decomposition of Capitalism and its Critics
Anselm Jappe, Alastair Hemmens
A new approach to the meaning of social emancipation.
Paperback: 978-1-78535-581-3 ebook: 978-1-78535-582-0

Enjoying It
Candy Crush and Capitalism
Alfie Bown
A study of enjoyment and of the enjoyment of studying. Bown
asks what enjoyment says about us and what we say about
enjoyment, and why.
Paperback: 978-1-78535-155-6 ebook: 978-1-78535-156-3

Ghosts of My Life
Writings on Depression, Hauntology and Lost Futures
Mark Fisher
Paperback: 978-1-78099-226-6 ebook: 978-1-78279-624-4

Neglected or Misunderstood

The Radical Feminism of Shulamith Firestone
Victoria Margree
An interrogation of issues surrounding gender, biology,
sexuality, work and technology, and the ways in which our
imaginations continue to be in thrall to ideologies of maternity
and the nuclear family.
Paperback: 978-1-78535-539-4 ebook: 978-1-78535-540-0

How to Dismantle the NHS in 10 Easy Steps (Second Edition)

Youssef El-Gingihy
The story of how your NHS was sold off and why you will
have to buy private health insurance soon. A new expanded
second edition with chapters on junior doctors' strikes and
government blueprints for US-style healthcare.
Paperback: 978-1-78904-178-1 ebook: 978-1-78904-179-8

Digesting Recipes

The Art of Culinary Notation
Susannah Worth
A recipe is an instruction, the imperative tone of the expert,
but this constraint can offer its own kind of potential. A recipe
need not be a domestic trap but might instead offer escape –
something to fantasise about or aspire to.
Paperback: 978-1-78279-860-6 ebook: 978-1-78279-859-0

Most titles are published in paperback and as an ebook.
Paperbacks are available in traditional bookshops. Both print
and ebook formats are available online.
Follow us at:
https://www.facebook.com/ZeroBooks
https://twitter.com/Zer0Books
https://www.instagram.com/zero.Books